IMAGES
of America

LOS OSOS/
BAYWOOD PARK

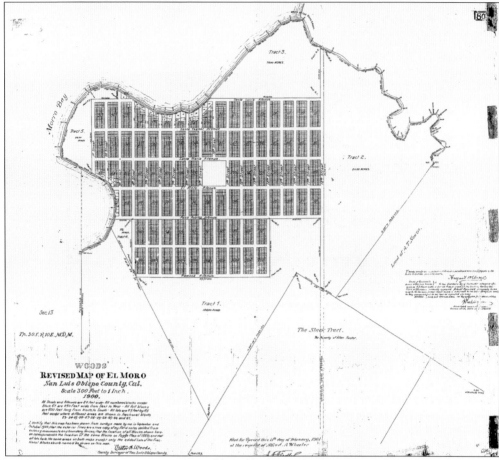

In 1889, an investment group represented by Alfred A. Wheeler requested a surveyor's map from San Luis Obispo County for the area at the end of subdivision 79 of the old Cañada de Los Osos Rancho. Many other areas along the Los Osos Valley had been carved out of that original property for dairy farming and sheep ranching. El Moro, as the proposed town was then called, was mostly vacant, sandy hills. The group hoped that the Southern Pacific Railroad would route its line along the coast, rather than inland down the Cuesta Grade. A narrow-gauge rail line was started in the Chorro Valley with a pass into the Los Osos Valley. The 3,000 lots marked with redwood stakes were optimistically planned to build a second San Francisco, with elegant homes and orderly neighborhoods. A large site for a hotel was left open in the middle. However, a crucial bridge needed to make this a reality was deemed too costly, and the development was abandoned and forgotten by 1894. (Courtesy of San Luis Obispo County, County Surveyor.)

ON THE COVER: This pier was one of several built in Baywood and Cuesta-by-the-Sea. Often their use was dependent on the tides and the boats' drafts. Piers would be rebuilt and lengthened as the salt marsh doubled in size over the years and parts of the bay filled in. Three dredging projects were proposed; one was started and never finished, and the others were abandoned. (Courtesy of Dean Sullivan, Sullivan Studios.)

IMAGES
of America

LOS OSOS/ BAYWOOD PARK

Lynette Tornatzky

Copyright © 2016 by Lynette Tornatzky
ISBN 978-1-4671-2409-6

Published by Arcadia Publishing
Charleston, South Carolina

Printed in the United States of America

Library of Congress Control Number: 2016945907

For all general information, please contact Arcadia Publishing:
Telephone 843-853-2070
Fax 843-853-0044
E-mail sales@arcadiapublishing.com
For customer service and orders:
Toll-Free 1-888-313-2665

Visit us on the Internet at www.arcadiapublishing.com

To the people of Los Osos/Baywood Park, at the coast and in the valleys, from the past and from today, who wrote this book with their stories. (Author's collection.)

CONTENTS

Acknowledgments		6
Introduction		7
1.	The Northern Chumash and Their Home	9
2.	The Valley of the Bears, Pecho Coast, and Clark Valley	17
3.	Real Estate Bust, then Boom!	47
4.	Los Osos, at Long Last	73
5.	Community	83
6.	Parks and Open Space	105
7.	The Infamous Sewer and Self-Governance	121

ACKNOWLEDGMENTS

Many, many thanks go to Joan Sullivan, my friend, guiding beacon, and inspiration. Our weekly coffees have kept me on track. Her stores of local history material, and stories of this town's history that we both love, are on every page of this book. My gratitude goes to the people of Los Osos/Baywood Park, the Los Osos Valley, Clark Valley, and the Pecho Coast, without whose help there would be no soul to this book, just an accounting of facts. My everlasting thanks to the San Luis Obispo History Center, whose guidance, hospitality, and patience gave me hope that this book could be accomplished. Some pieces of this story were found as far away as the Smithsonian Institution, and the San Luis Obispo county maps are a treasure that more should explore online. I encourage everyone to dig for history, record it, and preserve it.

I wish I could name everyone who contributed to these pages, but the first chapter would have been forfeited. I do thank the people who disrupted their lives to hunt for old photographs, some of which brought back strong memories, sad and happy. This is a small town and geographically a small area. But the stories are large, and there are far more out there than could possibly fit on these pages. I hope I have done justice to your input, friends and neighbors, and any mistakes on these pages are mine alone.

As I finish writing, I can now thank George "Will" Kastner for coming up with the idea to write this book, which blossomed from a Celebrate Los Osos task of creating a map of interesting sights around town to a book I didn't know I could write. I think this is like what he intended for the mural projects that he shepherded back in the 1980s and 1990s—that we work together to make something that benefits us all.

I hope old-timers will find lost friends in this book and the rest of us find a larger pride, an inspiration in the vision, and a willingness to advance from the people on these pages and love anew where we are lucky enough to live.

Introduction

The town that is officially called Los Osos, where the Baywood Park name just won't suffice, got a late start—in the 1920s—compared to most others in San Luis Obispo County. Los Osos owes its name to its Spanish/Mexican heritage and being at the terminus of the Valley of the Bears. Early developer Richard Otto, who rightly thought the original name of the area, El Moro, was too much like Morro Bay, decided upon a new name, Baywood Park. Otto's new moniker has never been forgotten in connection to Los Osos wherever there is the slightest discussion of local history. To the Post Office, we are Los Osos, though the name really just describes our location on a modern map. Neighborhoods are more descriptive for locals who call out their own housing area to other locals.

It might be hard for the casual visitor to imagine much of a history here, as many travel straight through town on the broad road to Montaña de Oro State Park that bisects the business district. Passersby will see only relatively modern stores and gas stations on either side, with many vacant lots in between. Certain histories, in every town, are hidden in plain sight, but here, one must dig deeper.

There are no stately government buildings or historic neighborhoods designated on maps, but there is some visual history in plain view—the stories on the murals decorating the sides of several buildings in town. The nature preserves and trails reveal the deeper and mysterious history of the earliest residents, the Northern Chumash. The modern architectural wonders are hidden and much less obvious than the parks and nature preserves in and around the town. Lost are many of the humble early buildings that really defined who we were back then. Some of those will appear on the pages that follow.

While most of the country began modernizing by the 1930s, ours was a primitive area, though only in physical comforts. The people were smart and tough. Much of the land was vacant well into the 1960s. The population of both Baywood Park and Los Osos was just 600 in the 1950s. In the 1960s, our population grew to 1,480 residents when the communities began growing together, finally exploding to 10,933 by the 1980s.

Old-timers say that the comity between neighbors vanished when so many people moved here so quickly. While physically the town grew together to be one, the community itself separated, and so many events nurtured by civic organizations stopped being yearly traditions.

Gone are the days when geese would come up on land by the pier at Second Street and beg for food. Gone is the sight of Richard Otto flying his plane onto Eleventh Street and down to the bay. Gone are the days anyone could navigate the waters near the pier, which the mud has filled in so high. But the feeling of acrimony has been dissipating. Relative newcomers are becoming the old-timers. The newest people don't know the divisions. They can read the history without having to feel it and can move ahead with their own ideas of their hometown.

Los Osos/Baywood Park is the only town in San Luis Obispo County that is not on a major highway, and that may be part of why it is different—happily isolated, left to grow with fewer imposed influences, and comfortable in its own skin, even as it sheds identities every few decades. Only a shadow of what really happened is on these pages, but it is a start for understanding what this life has been about.

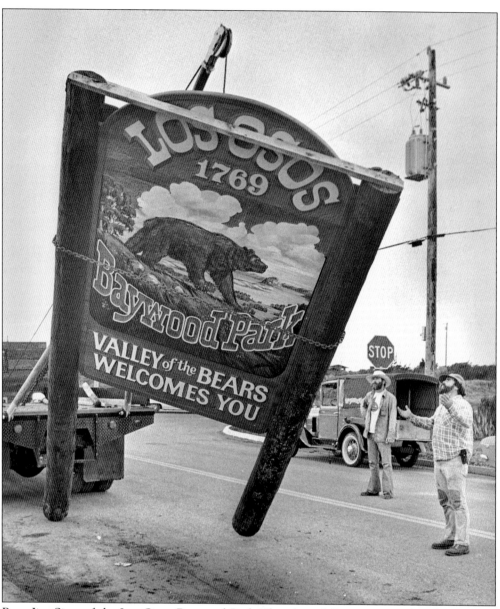

Pres. Jim Sims of the Los Osos–Baywood Park Chamber of Commerce and architect Tom Courtney are both credited for instigating the large redwood signs for the two entrances to town in 1978–1979. This was an attempt to counter the bumper sticker of the day, "Where the Hell is Los Osos?" Artist Robert Brooks carved and painted them. One remains where it was originally placed on South Bay Boulevard near Santa Ysabel Avenue. As the South Bay Boulevard sign was being hoisted into place, it broke loose and hit the asphalt. It was repaired and up the next day. The other, on Los Osos Valley Road near the cemetery, was struck by a drunk driver and partially demolished. Brooks was tasked with carving and painting a replacement. That sign was moved closer to town and placed on the opposite side of the road. A private citizen commissioned Brooks to repair the damaged sign, and it lives now in that citizen's front yard. It is unclear where this 1979 photograph was taken; it matches neither original location. Pictured are Ted Miller (left) and Bob Cabaniss (right). (© the *Tribune*/Wayne Nichols.)

One
The Northern Chumash and Their Home

The Northern Chumash people inhabited the Los Osos–Montaña de Oro area for 10,000 years or more. They had a complex society of villages and trade that has left many traces on the land in this area, some hidden, others in plain sight. There was once a thriving populace with extended kinships and many artistic expressions. They thrived for thousands of years because they understood their environment, including the changing seasons, animal migrations, tides, the stars, and weather patterns. The Spanish and Mexican eras in the 18th and 19th centuries decimated this population by removing the people to the missions, by disease, and by scattering the people onto ranches and into towns. These survivors' descendants still live in San Luis Obispo County and are revitalizing their elegant culture, language, songs, and dances.

The name "Chumash" is not the one the people themselves use today. Rather, they are Yak Tityu Tityu, "the People." The Northern Chumash language is considered the oldest of the eight Chumash types, and while Obispeño is used to identify it, that is a Spanish word, not one used by the People today.

Many town names today were derived from Chumash words: *pismu'* became Pismo Beach, *lompo'* became Lompoc, *nipumu'* became Nipomo, and *wasna* became Huasna. The basketwork of the Yak Tityu Tityu is regarded as among the finest of the native peoples of America. Unique to Native Americans, they built their beds high on bedsteads with a reed mat for a mattress and four other mats on posts to form curtains.

The People made the necessary tools to rely on hunting, gathering, and fishing to live, and they efficiently managed those resources. They processed shellfish in specific places, casting off the shells in refuse piles, called middens, so one can see what they ate for some of their meals. Other food included marsh birds, small animals such as rabbits, and deer. Written records from the Spanish era include oak acorn mush and roots.

The Northern Chumash peacefully survived on this land far longer than the 230 years of the current civilization; modern Californians might learn something from them.

The geology of the coastal region that underlies Los Osos/Baywood Park and the valleys is sand dunes and rock. But before that, there was molten magma, tectonic upheavals, sea level rises, erosion, and sedimentation. It is believed that the magnificent Nine Sisters Peaks, which line the Los Osos Valley right out into the ocean, originated at approximately the same latitude as Palm Springs, California. They were moved north, sitting on the shifting Pacific Plate. What one sees today are the degraded remains of the dacite volcanic plugs after 20–25 million years of erosion.

There are really 14 peaks, but only nine have names: San Luis Mountain, Bishop Peak, Chumash Peak, Cerro Romualdo, Hollister Peak (originally called Cerro Alto), Cerro Cabrillo, Black Hill, Morro Rock, and the Davidson Seamount, which is underwater. The Sisters are of cultural significance to the Northern Chumash. (Photograph by Alvin Rhodes, courtesy of Joan Sullivan.)

Evidence of Northern Chumash life spanning their occupancy for thousands of years abounds in Los Osos. These broken shells are along a path in town. The village itself in Los Osos likely ended around 1800. The town has been built on top of their civilization, and archeological assessments for Northern Chumash artifacts are often needed before construction is allowed. (Author's collection.)

Tule balsas were used in protected areas like Morro Bay for fishing. They were made out of bullrush that was dried and made into bundles, which included one willow pole per bundle for strength. The bundles were then tied together to form a seatless boat. This 1817 print by Louis Choris depicts San Francisco Bay, but the local Morro Bay craft would have looked similar. (Courtesy of the University of California Berkeley, Bancroft Library.)

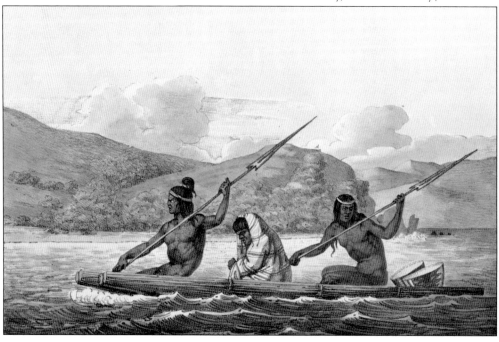

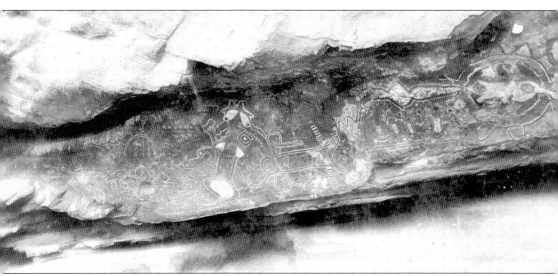

Sacred sites to the Northern Chumash were many and include Morro Rock and the horseshoe-shaped sandstone rock formation known today as Painted Rock at the Carrizo Plain National Monument. These sites remain sacred to the native people who are still around today. At one time, the paintings extended more than 40 feet in length. Chumash painted both representational and abstract images, with black, red, and white being the most common colors. Painted Rock was used as a meeting and gathering place for the Chumash and the Yokut people and possibly other native groups. Heavily worn footpaths on the large outcrop are evidence at the site of centuries if not thousands of years of native ceremonies. The polychrome paintings were more likely first put on the rock at least 1,000 years ago and continued to be repainted into historic times. This site has been heavily damaged by erosion, and in the last century, nearly totally destroyed by gunfire. Painted Rock is now a protected Bureau of Land Management site with limited visitation. (Photograph by Lorenzo Yates, courtesy of the Santa Barbara Museum of Natural History.)

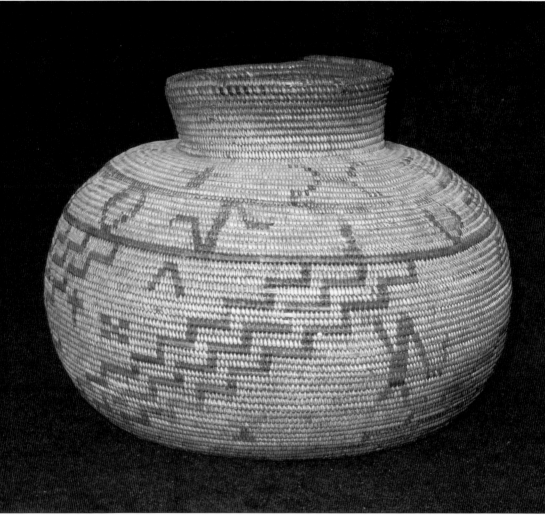

The Northern Chumash are known for their superb basket making. This San Luis Obispo County coiled basketry jar is decorated in stair-step block cascades. The unusual designs of unknown meaning on the body and shoulder may have been copied from letters. These designs were woven in, using naturally colored plant materials—rush stems, sedge runners, and tule roots. A single white bead, its significance unknown, was woven into the side of this basket. Coiled baskets were used for preparing food, for storing seeds, as trays, as burden and trinket baskets, and as women's hats. Twined baskets were used for fishing, harvesting seeds like chia sage, straining, leaching acorn flour, and water storage. Some cooking baskets were so tightly woven that they held water. Water storage baskets lined in asphalt ranged in size from a water bottle to one big enough to hold two or three gallons. Today the Northern Chumash are once again learning the intricate art of basket making and hope for access to traditional plant materials. (Courtesy of the Santa Barbara Museum of Natural History.)

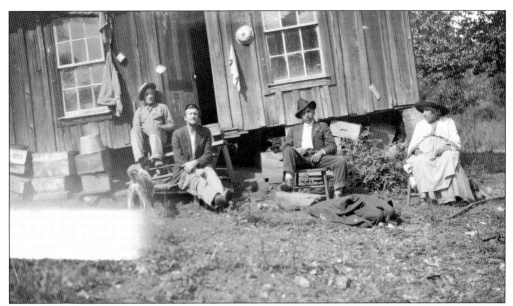

Rosario Cooper, a Yak Tityu Tityu, is recognized as the last speaker of the Obispeño Chumash language in San Luis Obispo County. She lived from October 7, 1845, to June 15, 1917. The collaboration between Rosario Cooper and linguist and ethnologist John P. Harrington saved the language from likely extinction. They worked together for many weeks over several years recording her songs on wax cylinders. Because of this effort, specific details of a Northern Chumash woman's life are known, and family kinships and culture that otherwise would have been lost are also understood. Rosario had one child who survived infancy, and his name was Francisco Olivas. Olivas has descendants who still live in San Luis Obispo County and throughout the state. Pictured from left to right are Mauro Soto, John P. Harrington, Frank Olivas Jr., and Rosario Cooper. (Both, courtesy of the National Anthropological Archives, Smithsonian Institution: above, 91-31415; below, 1976-95.)

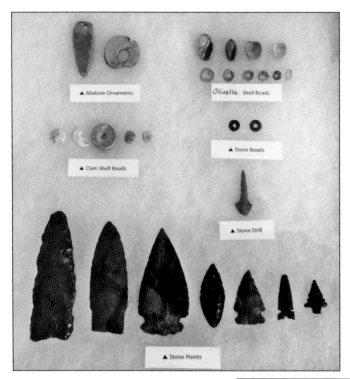

These handmade replicas of Northern Chumash artifacts (which were modeled from the originals) are used for teaching in schools and at public educational events. The projectile points were often made of chert and sometimes of imported obsidian. They were attached to arrows and javelins to hunt deer. Drills made holes in shells and stone for ornamentation and to string shell bead money. (Courtesy of the Yak Tityu Tityu, Northern Chumash tribe.)

Awls were used in basket making. Flutes were one form of music making, but there were also various percussive instruments. Game pieces could be of bone or shell and could be used in games of skill and chance. Much research is ongoing, including research conducted by Northern Chumash scholars to discover the uses and dating of these artifacts. (Courtesy of the Yak Tityu Tityu, Northern Chumash tribe.)

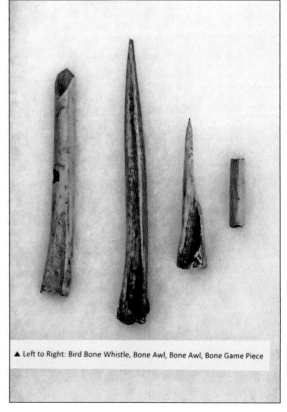

Two

The Valley of the Bears, Pecho Coast, and Clark Valley

The central coast of California was first seen by Europeans in 1542. The Los Osos Valley was explored in 1769 by Gaspar de Portolá and his men, and documented by Fr. Juan Crespí and Lt. Miguel de Costansó. They named the Valley of the Bears. The summary of the valley's history from then on could be discovery, settlement/displacement, and changing economic models.

King Carlos III of Spain sent Capt. Gaspar de Portolá y de Rivera to Mexico to close down the Jesuit missions, to establish Alta California colonies and Franciscan missions for Spain, and to claim land before the English and Russians could claim more. Successful in his quest, padres, soldiers, and settlers soon followed, and the mission and pueblo San Luis Obispo de Tolosa was established in 1772. The Chumash population was subsumed into mission life, thus ending their 10,000-plus years of a singular lifestyle.

Mexico achieved independence from Spain, and the mission system was divested of its land holdings by way of land grants to prominent Mexican citizens, non-Mexicans who married Mexican women and converted to Catholicism, and some Native Americans. John Wilson and James Scott (who later sold out to Wilson) bought the Los Osos Valley, the lands now called Montaña de Oro, and Clark Valley. Cattle ranching thrived in the valley and the entire central coast until the great drought of 1862–1864, which brought a devastating reversal of fortunes from which the ranches did not recover.

After the drought, the vast land holdings of Wilson's heirs were sold to pay debts and were carved up into smaller parcels. They were bought by immigrants, particularly from Portugal's Azores and by Italian Swiss and Yankees, all willing to start life in America by farming and dairying. This brought prosperity for those willing to work hard and who had some good luck.

Capt. Gaspar de Portolá led 63 men and 180 animals north from Baja California on May 15, 1769. The troop arrived on September 7 at "an arroyo of good water . . . on whose banks we camped," according to the diary of Fr. Juan Crespí. This was likely Los Osos Creek or Warden Creek. Bears were abundant, hence the name "the Valley of the Bears." Portolá, an aristocrat from Catalonia, Spain, was California's first governor. (Courtesy of the *Herald-Examiner* Collection, Los Angeles Public Library.)

Spanish expeditions of the 1700s included priests, and sometimes the place where Mass was held would be marked with a cross. Mass was said in the Los Osos camp on September 7, 1769. A very old oak tree found in the approximate area of the camp was marked with a Spanish-style cross. The mark could also have been carved to denote a boundary from the Spanish and Mexican land grant times. (Courtesy of Dennis Sheridan.)

Pedro Fages, a leader in Portolá's expedition in 1769, returned to the Valley of the Bears as commander of the presidio of Monterey, looking for food. The supply ships were late, and both the presidio and Mission San Antonio de Padua inhabitants were starving. His three-month expedition, manned with 13 soldiers, killed 30 bears; both soldiers and mission workers survived. Fages is pictured here in a c. 1770–1790 painting by an unknown artist. (Wikimedia Commons.)

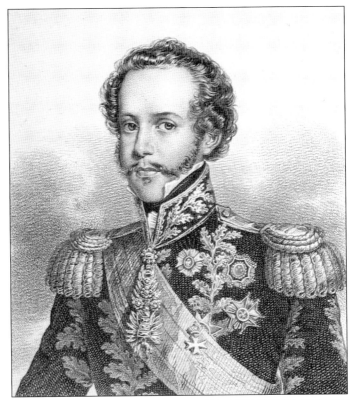

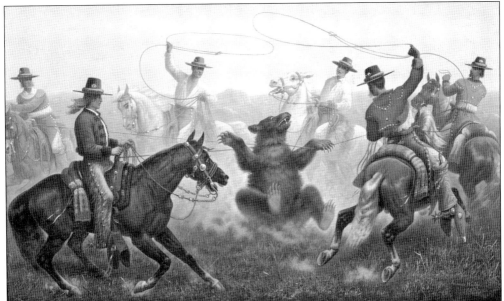

Grizzly bears were native to Los Osos Valley. The Chumash dealt with them by feeding them poisoned meat. Europeans encountered them in 1769 and shot them for food, and when settled here, for the protection of their animal herds. The valley still had a bear population in the 1840s–1850s. This 1877 painting by James Walker, *Cowboys Roping a Bear*, shows one being captured. (Courtesy of the Google Art Project.)

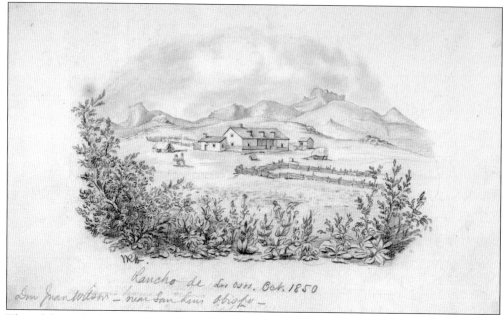

This adobe in the Los Osos Valley belonged to Capt. John Downes Wilson and his wife, Ramona Carrillo de Pacheco y Wilson. The house was 90 feet long, and most of the walls were three feet thick. There were two floors and 10 rooms. The fireplace was of Italian marble. This sketch is from 1850. (Courtesy of the William Rich Hutton Collection, HM 43214 (42), Huntington Library and Art Gallery.)

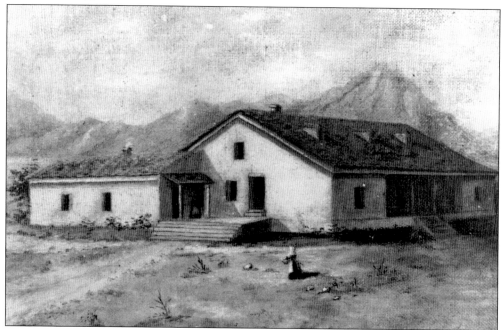

Lizzie La Tourette Warden, a later Los Osos Valley resident, painted the Wilson adobe in January 1897, almost 50 years later. The Battista and Elena Turri family moved into the house in 1901. The smaller buildings on the left were removed after the 1906 earthquake made them unsafe. The main building still stands today. (Courtesy of the History Center of San Luis Obispo County.)

A woman reputed to be Ramona Carrillo de Pacheco y Wilson poses with a little boy. There is no verified portrait of her husband, Capt. John Wilson, either. Ramona Wilson was born on July 24, 1812, one of 13 children of a judge in Santa Barbara. Her first husband, Capt. Mariano Pacheco, died at the Battle of the Cahuenga Pass in 1831. She married Capt. John Wilson on November 9, 1835. They moved from Santa Barbara to San Luis Obispo around 1845, then to their ranch in the Los Osos Valley. This ranch, with their other holdings, made the Wilsons the richest family in the county (established in 1850 with California's statehood). In addition to the two sons Ramona had with her slain husband, the Wilsons had three daughters and a son. Ramona owned land in her own right; she was granted the 48,834-acre Rancho Suey in 1837 by Gov. Juan Alvarado. She was widowed again when her husband John Wilson died in 1861. She died December 17, 1886, in San Francisco. (Courtesy of the History Center of San Luis Obispo County.)

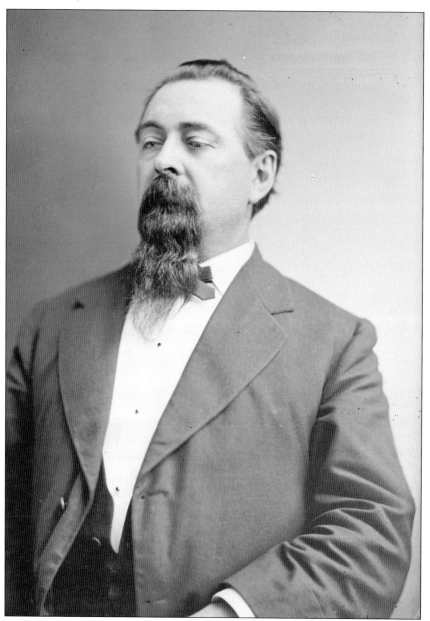

Romualdo Pacheco was the stepson of Capt. John Wilson. His father, Capt. Mariano Pacheco, was killed at the battle of the Cahuenga Pass in 1831. This photograph was taken between 1865 and 1880. Pacheco was born October 31, 1831. He went to school in Hawaii along with his brother, Mariano, and learned three additional languages at a time when only 40 children spoke English in addition to Spanish in the county. He apprenticed on a trading vessel and returned to California in 1848 to work on his stepfather's ranchos. He later became a San Luis Obispo County judge, a state senator (twice), state treasurer, lieutenant governor, governor, and a US congressman. He was a US envoy and minister plenipotentiary to Central America and minister plenipotentiary to Guatemala and Honduras. He died on January 23, 1899. Between 1862 and 1864, after his father's death, he sold Cañada de Los Osos Rancho at a greatly reduced rate after a devastating drought. (Courtesy of the Library of Congress.)

San Luis Obispo County went through a period of lawlessness in the 1850s. Bandits waylaid ranchers returning from cattle sales in Santa Barbara and Los Angeles, took their money, and left no witnesses; skeletal remains were a common sight on El Camino Real. The most famous gang, the Jack Powers Gang, had a member who was the son of Victor Linares, a former landowner in Los Osos Valley who had sold his La Cañada de Los Osos Rancho to John Wilson and his partner. Pio Linares was tracked down by the San Luis Obispo Committee of Vigilance to the land his father once owned. He hid out overnight in a willow thicket thought to be near the present Turri Road. In the morning, Pio Linares and the gang fired on the Vigilance Committee; they fired back. Linares was killed on the spot with a shot to the head on June 13, 1858. (Courtesy of the History Center of San Luis Obispo County.)

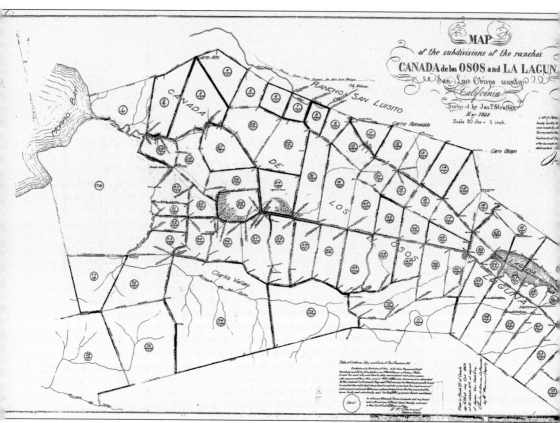

The Valley of the Bears, or Cañada de Los Osos, passed through many hands. It was originally claimed by Filomeno Pico. It was granted however to Victor Linares by Gov. Juan B. Alvarado, then it was purchased by John Wilson and James Scott in 1844 and combined with Rancho Pecho y Islay in 1845 by Gov. Pio Pico. Cañada de Los Osos was willed at his death in 1861 to Wilson's son John (Scott had been bought out), but it was sold by Wilson's stepson Romualdo Pacheco in 1865 to Timothy G. Phelps. This map, drawn in 1868, shows the many divisions of the original ranch. The original grant was not patented to Wilson until 1869, after his death. The complicated and unclear property boundaries caused these sorts of delays in title claims fairly often. Three years of drought ushered in the end of the ranchos and the beginning of the Swiss-Italian and Portuguese immigrants who farmed grain and hay and raised cows to produce the butter and cheese that was the next big wave of coastal commerce. (Courtesy of San Luis Obispo County, County Surveyor.)

Two Warden brothers settled in the Los Osos Valley after the ranchos had been subdivided. The younger brother, Horatio Moore Warden, purchased lots 40 through 47 and later lot 18. He raised short-horned Durham cattle. Horatio's son William later purchased lot 35 of the rancho. In 2012, part of these lands was preserved in perpetuity by a conservation easement. Wardens still live in the valley and have been prominent citizens of the county for over 100 years. (Courtesy of the History Center of San Luis Obispo County.)

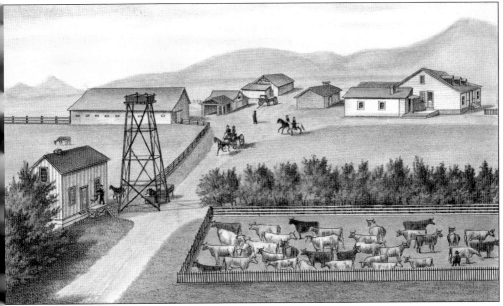

The elder Warden brother, Lewis Moore Warden, purchased lots 21, 24, and 25 of the former rancho in the fall of 1871, which included the adobe formerly occupied by John Wilson and Ramona, the original owners of the entire rancho. He raised 12,000 head of sheep until the drought of 1876 forced him to quit that business. (Courtesy of the San Luis Obispo County Regional Lithographs Collection, Special Collections and Archives, Cal Poly.)

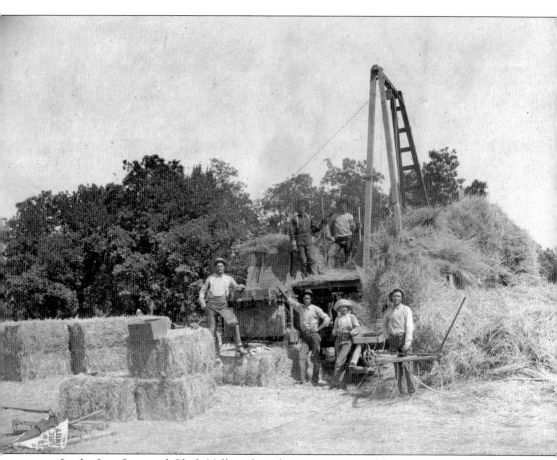

In the Los Osos and Clark Valleys, hay that was not stored loose in barns was baled using a stationary hay press. This worked by men loading the hay into a square chute, then depressing it using a lever-operated, jack-type ratchet. The wire was wrapped by hand, then the bale was ejected. It required at least five men to operate. Balers that directly picked up the hay from the windrows did not come on the market until 1933. (Courtesy of Craig Beecham.)

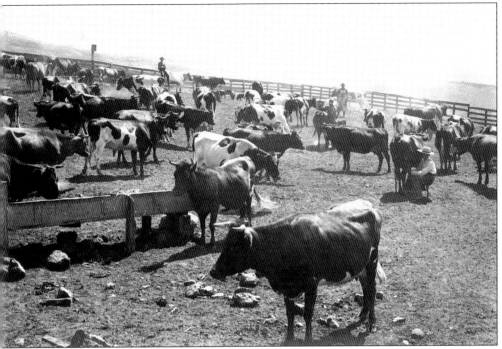

Once the drought of 1862–1864 was over, so was cattle ranching for meat and hides as the exclusive industry in the Los Osos Valley. Dairy cows, sheep, hogs, and field crops were profitable enterprises for the many farmers who bought sections of the old Cañada de Los Osos Rancho. (Courtesy of the History Center of San Luis Obispo County.)

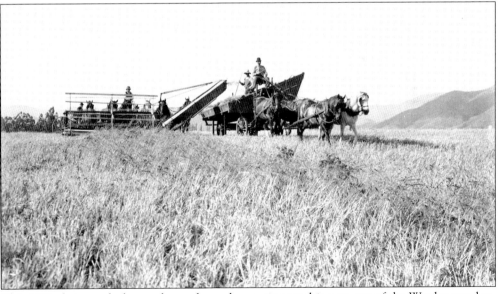

This 1901 photograph shows a horse-drawn harvesting machine on one of the Warden ranches. One year, the *San Luis Obispo Tribune* reported that L.M. Warden's land yielded 42 sacks (76 bushels) of barley per acre, weighing on average 102 pounds. He made $21.10 per acre. Twenty-five bushels remained on the ground, and Warden turned 100 head of hogs on the gleanings. (Courtesy of the History Center of San Luis Obispo County.)

The Andrew Fowler Bagley ranch was on lot 4 of the old Wilson ranch, near Cerro Alto, as Hollister Peak was called prior to 1880. The Bagley property was next to the B.B. Pierce land. In 1878, Bagley and Pierce sowed 90 acres of flax and received $3,500 for their efforts. Rust had ruined other farmer's wheat crops that year. (Courtesy of Debbie Farwell.)

Alexander Hazard, a farmer and dairyman, owned Wilson land (and adjacent government land). Besides beans, he grew eucalyptus trees in rows like crops, hoping to harvest them for building purposes. Unfortunately, this young and unseasoned wood did not work for uses other than firewood. Hazard's ranch buildings on the Pecho Coast were wiped out by flood and fire in the 1940s. His name and the trees remain today in Montaña de Oro State Park. (Author's collection.)

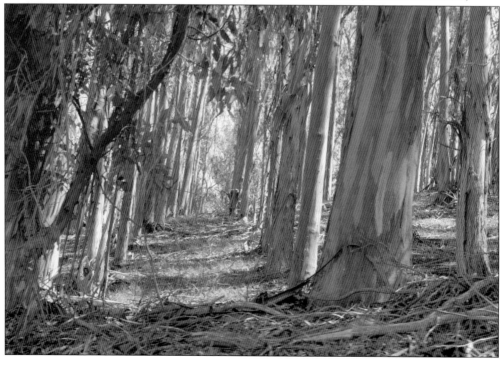

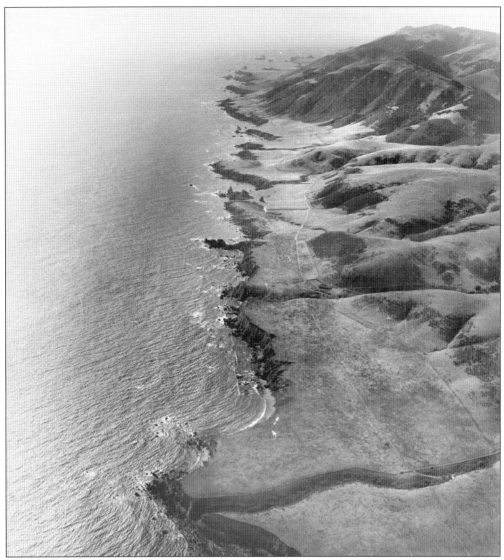

This area, once known as Rancho Pecho y Islay, was first granted to Francisco Badilla in 1843 by Gov. Manuel Micheltorena, although Francisco Xadello was listed in records as an earlier claimant. The Pecho was combined with Rancho la Cañada de Los Osos to the north in 1845 by Gov. Pio Pico; the latter was already owned by John Wilson and his partner James Scott. The Chumash inhabited this area in earlier times for thousands of years and left many remnants of their life. A ranch building can be seen in the lower right at Pecho Creek, which only emphasizes the vastness of the land and the isolation from civilization. When Wilson died, the rancho was inherited by his daughter Ramona Wilson Hilliard. She leased portions of the ranch and later sold it. The immense cattle ranch of La Cañada de Los Osos y Pecho y Islay ended in fragmentation and farming. (Photograph by Martin Litton, courtesy of the Harold Miossi Papers, San Luis Obispo County Environmental Archives, Cal Poly.)

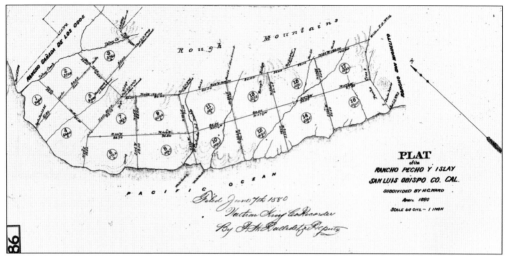

Ramona Hilliard was delinquent on taxes for Pecho y Islay by $304 in 1878. Hilliard had to forfeit the ranch at a public auction on July 12, 1880. Of the 17 lots listed on the plat map, only lot 16 (with 632 acres) lists an improvement on the tax rolls. It is likely the building below. (Courtesy of San Luis Obispo County, County Surveyor.)

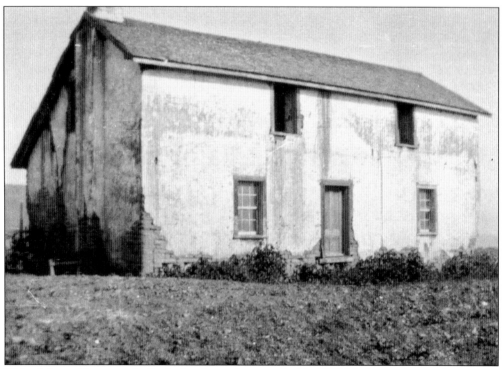

This adobe residence on the Pecho land was photographed in 1928. Nothing is known for certain, but it was probably built during the mission era and later used by John Wilson's ranch hands while tending his cattle. The adobe was at the south boundary of the Pecho y Islay grant. It was torn down in the 1960s. (Courtesy of the History Center of San Luis Obispo County.)

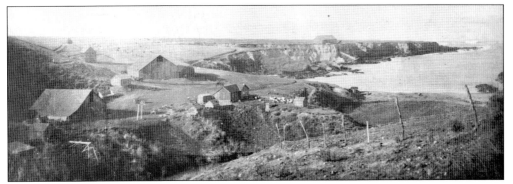

Alden B. Spooner Jr. leased Pecho ranch land from Henry Cowell in 1892, later buying it in 1902. His success as a farmer and rancher allowed him to buy more property, eventually totaling about 9,000 acres. His sons Quincy, Carl, and Alden III, along with Japanese sharecroppers, continued their farming until the early 1940s, when the ranch was sold. (Courtesy of the California State Parks and the Central Coast State Parks Association.)

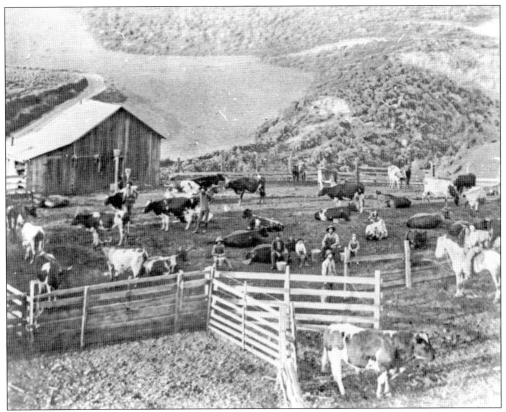

Alden Spooner Jr. was a successful dairyman. He mechanized the work of his cream separator and butter churn by building a dam and pond. Water was released down a series of trenches and flumes, eventually powering a waterwheel with belts and pulleys to do the work. He hauled crops on a paddle-wheeled, horse-driven flatboat from Shark Inlet across to Morro Bay. (Courtesy of the California State Parks and the Central Coast State Parks Association.)

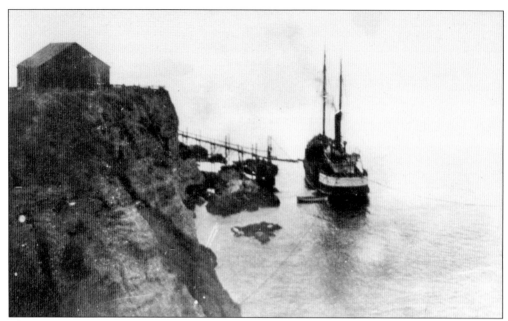

The Spooner ranch was too isolated to join one of the county creamery cooperatives. Fortunately, the water was deep near the south cliff at Spooner's Cove, and a ramp and trestle could easily accommodate the coastal schooners. Butter, barley, peas, and passengers were shipped out to San Francisco in two days, and Canadian liquor was smuggled in during Prohibition. (Courtesy of the California State Parks and the Central Coast State Parks Association.)

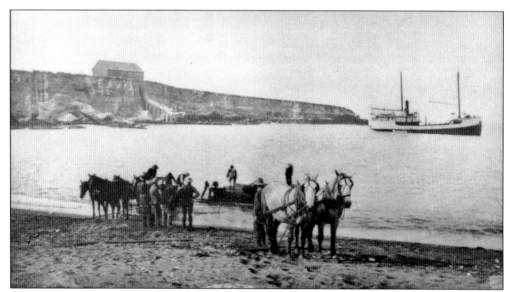

Alden Spooner Jr., with his brother Cornelius, devised a landing below the cove bluff and a chute to move bales and bags down to waiting ships, alleviating the problem of getting produce to market. Their warehouse can be seen on the bluff. Sometimes, though, a barge was necessary to transport goods to waiting ships. (Courtesy of the California State Parks and the Central Coast State Parks Association.)

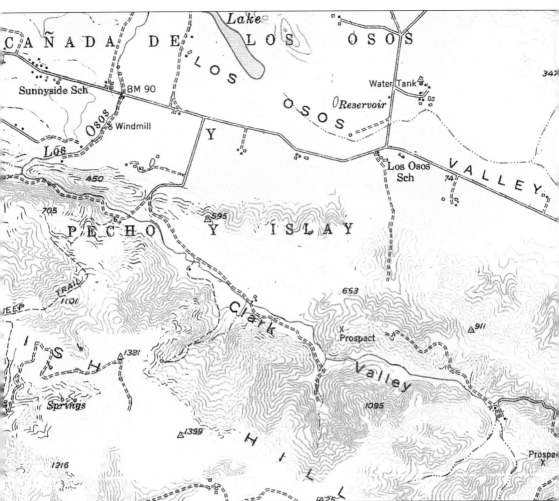

Dairy and farming were not the only enterprises on the old ranch lands. There was mining in both the Los Osos and Clark Valleys. Floride Frost Welsh, born in Clark Valley in 1900, recalls there being a manganese mine that was covered over after World War I (along with an eight-to-nine foot fossilized lizard). That mine was mainly located on lot 74 of the Rancho La Cañada de Los Osos on the ridge south of Clark Valley. The US Refractories Company owned a chalk mine in Clark Valley with findings of the finest quality for face powder and insulating brick. In 1901, Gen. J.M. Gleaves, the US surveyor general for California, owned the Los Osos Mining Company (formerly the Goodwill Copper Mine). But he was reviving it from its initial start around 1860. A few loads of ore were shipped to Swansea, Wales, but the return was eaten by the costs. Promising deposits of iron ore have been found but never mined. The final attempt at copper mining was made in July 1937. (Courtesy of the US Geological Survey.)

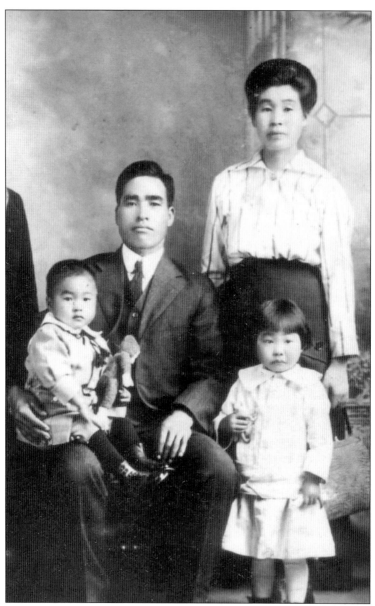

Tameji and Take Eto arrived in the Los Osos Valley in 1919 after farming and purchasing land in other parts of the county. Tameji Eto grew sweet peas for seed, then expanded into the old Rancho Pecho y Islay and other parts of the county, growing peas, lettuce, tomatoes, and other dry farming crops. He helped organize local farmers to bring telephone service into the valley. They sold $100 shares and started the Los Osos Mutual Telephone Company. Next Eto and others brought electric lines through the valley to Los Osos. In 1941, World War II began, and Eto was incarcerated. His family was placed in internment camps, the most notable being Manzanar. Eto leased his valley land to the local farmers; he and some of his family returned in 1945. After World War II, Congress established an exchange program to help recovering countries learn American farming practices. In 1951, Eto was one of the local sponsors of the program. The Etos became naturalized citizens in 1953, soon after the McCarran-Walter Act was enacted. From left to right are Tameji with son Masaji and daughter Alice in front and wife Take. (Courtesy of Alan Eto.)

Lawrence Lewis Guidetti married Rose B. Machado on October 30, 1919. They lived on a ranch in the Los Osos Valley. Son Lou Guidetti remembers a kerosene motor running the washing machine and a wood-burning stove. Electricity reached the farm in 1928. The dairy business had transitioned into farming, and Filipino men came to work the fields. Lou's tutor was a graduate of the University of Manila. When Lou got to the Los Osos school, he remembers spelling bees every other Friday. He loved the paper flowers that expanded in water that the Etos brought over from Japan. When older, he danced on the deck of John Rogers's house at Cuesta-by-the-Sea; he had gone halibut fishing with Rogers when he was a boy. The Los Osos school could be rented for $5, and many parties were held there by ranchers in the valley. Lou's father met his mother at one of these. (Courtesy of the History Center of San Luis Obispo County.)

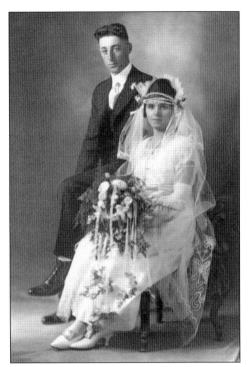

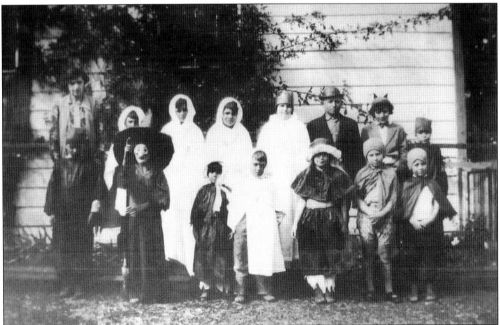

Children came in costumes for Halloween at the Los Osos school in 1928. From left to right are (first row) George Silvera, Edith Mello, LaVerne Guidetti, Eddie Gianolini, Amelia Gianolini, Edith Gianolini, and Louis Guidetti; (second row) Catherine Childs (teacher), Leslie Machado, Ernest Margaroli, John Silva, Lucille Margaroli, Etori Margaroli, Margaret Mello, and Tony Silva. They presented a play called *Shadows of the Moon*. (Courtesy of the History Center of San Luis Obispo County.)

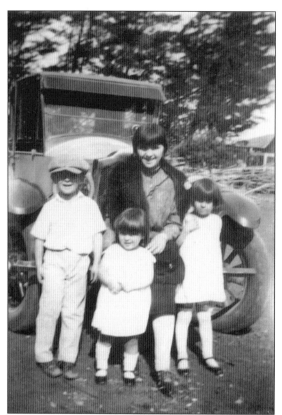

The Guidetti family poses with their aluminum-body 1921 Packard on the farm. From left to right are Lou, Elaine (in front), Rosie (mother), and LaVerne. On Sundays, the family drove to Baywood Park and shot rabbits to make stew for the workers and shot crows for blackbird pies. (Courtesy of the History Center of San Luis Obispo County.)

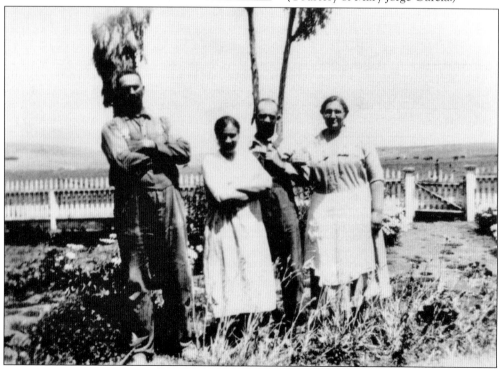

Many people who farmed and raised dairy cows in the Los Osos Valley had come here from the Azores. The Jorge family came the village of Cedros on the island of Faial, one of nine islands in the archipelago. They farmed beans, hay, grain, alfalfa, and sugar beets. From left to right are Francisco Pereira Jorge, wife Anna Peres Jorge, Joseph Peres (Anna's brother), and Madalena Jorge (sister of Francisco). (Courtesy of Mary Jorge Garcia.)

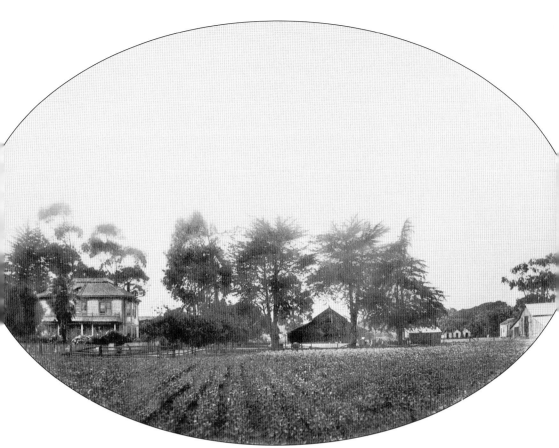

The Morganti home and farm was located near Los Osos Creek and the present corner of Lariat Drive and Tapidero Avenue. In the 1870s, the Morgantis owned extensive acres once held by Los Osos Valley pioneer Mark Elberg. The home had 17 rooms including three bedrooms, a long hallway, a bath upstairs, four bedrooms downstairs (one with a fireplace), a kitchen, two dining rooms, a parlor, a sitting room, a living room, a pantry, and a washroom. The Jorge family lived in this house from 1923 to 1932 and farmed. Albert (1927), Anna (1928), and Mary (1930) were born here, delivered by Dr. L.T. Wade of San Luis Obispo. (Courtesy of Mary Jorge Garcia.)

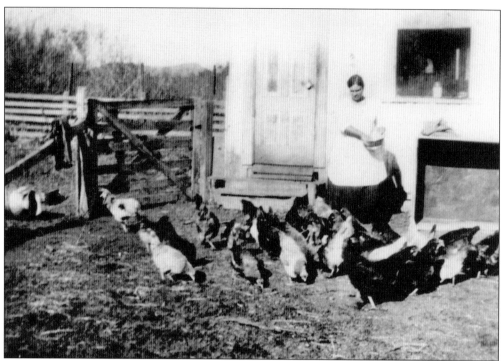

Above, in an undated photograph, Anna Peres Jorge feeds the chickens; a cabin on the ranch is behind her. Below is Anna Peres Jorge with her oldest child, Albert Joseph Jorge, and husband, Francisco Pereira Jorge, in 1928. They were married in San Luis Obispo on April 4, 1923, and moved onto the ranch. (Courtesy of Mary Jorge Garcia.)

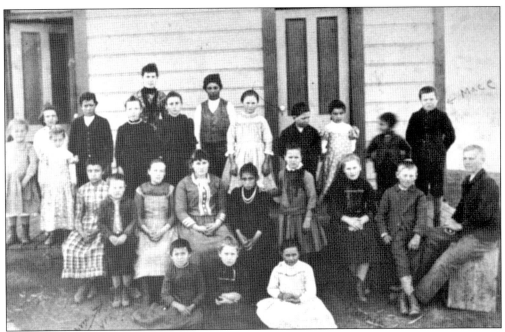

This is the 1893 class picture of the Los Osos School (founded in 1872). From left to right are (first row) Rachel (Kelly) Tonini, May Peterson, and Angelina Rusca; (second row) unidentified, Virginia Garcia, James Bagley, Grace Kelly, Ella Peterson, Tilda Tonini, Minnie Bagley, Lena Peterson, Johnny Peterson, and Louis Peterson; (third row) Lena Filipponi, two unidentified, Joe Dutra, Angelina Tonini, Josie Tonini, August Dutra, Alice Ebi, Tony Dutra, Mary Garcia, unidentified, and Mason Bagley. The teacher, Miss Morrison, is at the back. (Courtesy of the History Center of San Luis Obispo County.)

Pre-1900 Sand Hill School students pose in a field. From left to right are (first row) Amy Machado, unidentified, Carson Reid, Eddie Elberg, Ella Reid, Amelia Machado, Annie Bello, Mary Perry, Edith Peterson, Mary Bello, Enos Bello, and Domingo Machado; (second row) Annie Reid, Rosa Machado, Ella Elberg, Mary Reid, May Peterson, Willie Reid, Johnnie Peterson, Henry Elberg, Quincy Spooner, Carl Spooner, and Merlin Hazard. (Courtesy of the History Center of San Luis Obispo County.)

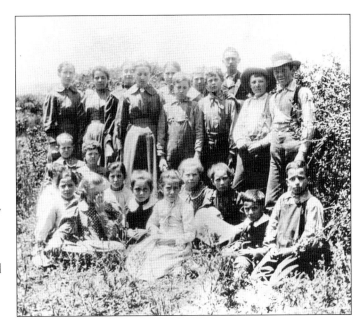

Andrew F. Bagley and his wife, Marion Elizabeth Orear Bagley, were Los Osos Valley pioneers. Their children were Minnie (left), born in 1882, James (below), born in 1884, Roy (opposite, top), born in 1887, and Mason (opposite, bottom), born in 1877. The three older children rode one horse to the Los Osos School. (Both, courtesy of Debbie Farwell.)

The Bagley family left the valley for Nevada in 1894 but returned five years later. Bagley sold the ranch to F. Bonetti in January 1917, but rental records show it was leased as early as 1912. Bagley also owned property in San Luis Obispo. He and his son Roy owned a laundry business there in 1914. Roy died young in 1919 from influenza. Bagley's relatives live in the county today. (Both, courtesy of Debbie Farwell.)

Clark Valley is adjacent to Los Osos Valley and was part of the old Cañada de Los Osos ranch. The story here began as a cure for homesickness. In the spring of 1869, Joseph Clark Welsh brought his Irish bride to the rolling green hills, which brought comfort, as they resembled those in Ireland. They bought ranch property, and Welsh's son continued cattle ranching and growing hay in 1898. Clark was an old family name that became the valley's name later on. In the 1920s, the area was called the Welsh's place. Names relevant to this area can be found in the San Luis Obispo newspapers and deeds of the 1880s and beyond: Reid, Cole, Johe, Gularte, Beecham, and Silva. (Courtesy of Virginia Severa.)

James and Armrel Beecham's Clark Valley ranch ran cattle in the 1950s, and the round-up below was on that ranch. Pictured here from left to right are unidentified, George Sousa, Henry Peterson, Alvin Bonetti, and unidentified. James Beecham's other job was running a heavy equipment construction company. The Beecham quarry supplied rock for many Los Osos roads, and Beecham graded the lot where Carp's Market was built in Los Osos. (Courtesy of Craig Beecham.)

A 1970s round-up on the Silvas' Clark Valley ranch was much the same as in the 1950s. Tony Silva was born in the 1920s. He married Mabel in 1956 and moved out to the Silva property in Clark Valley. The Silvas kept the old square grand piano that had once belonged to the Welsh girls, who sold it to the Gularte family for two bales of hay. (Courtesy of Virginia Severa.)

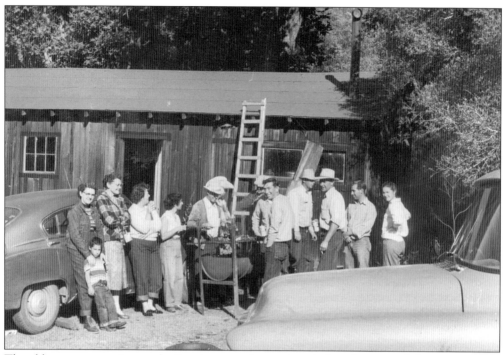

The old manganese mine on the Beecham ranch was there before they owned the property. An ore car and rails still remain. There were quarters built for the miners, but they burned down. The cookhouse is being used for a barbecue party in the 1950s. From left to right are four unidentified, Armrel Beecham, Curley Fry (barbecuing), unidentified (behind Fry), three unidentified, James Beecham, Alvin Bonetti, Bob Fry, and unidentified. (Courtesy of Craig Beecham.)

George Sousa was born into a Los Osos Valley pioneer family in 1895. His father came from the Azores, as did many valley dairymen after 1860. Sousa attended Sunny Side School from 1901 to 1905. As an adult, he worked as a cattle buyer and did grading on his ranch. He lived on the ranch until the house burned and later sold the property. He died rich but alone in a small trailer on a friend's ranch. (Courtesy of Craig Beecham.)

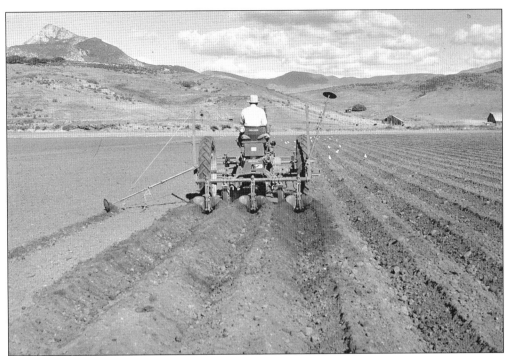

Tameji Eto returned to the Los Osos farm after World War II and continued working. He and his brother had already organized the San Luis Obispo Vegetable Growers Association. County crops were shipped to the East Coast, Los Angeles, and San Francisco via Wells Fargo, and later, to save money, Eto negotiated for US Post Office trains. After the war, the brand name San Luis was used on the shipping crates, with a picture of a padre, to ensure acceptance of his products in the marketplace. The Los Osos Farm Products Company ran its own trucks to the Los Angeles Produce Market six days a week. Fields are being prepared for lettuce above in 1952. At right, son Masaji Eto is pictured in 1946 with the lettuce that commanded a premium price. (Both, courtesy of Alan Eto.)

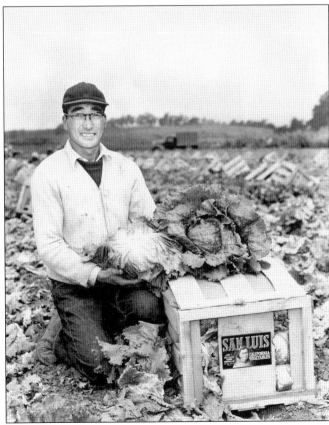

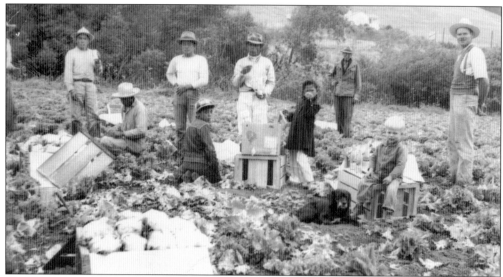

Filipinos first saw Morro Rock in 1587. The largest group to return to the area was in 1948, although there were small numbers of men doing farm work in the Los Osos Valley and at Spooner's ranch in the 1920s and the 1930s. Above, the Cortez family works a farm on Turri Road around 1950. (Courtesy of Albert Calizo.)

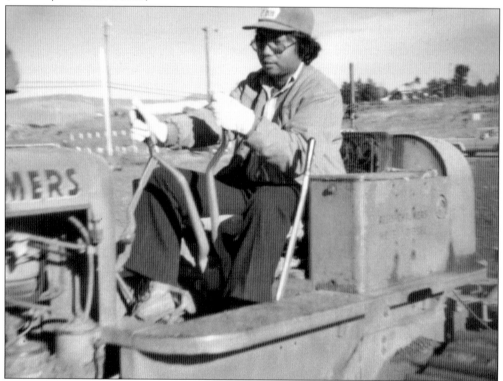

Another group of Filipino men arrived in the 1970s to work in the fields but soon moved on to other jobs. Dick Pacaoan was on a tractor then but now runs a business in Los Osos. Today there are around 120 family households with Filipino origins in Los Osos/Baywood Park. (Courtesy of Dick Pacaoan.)

Three

REAL ESTATE BUST, THEN BOOM!

There was no town in the Los Osos/Baywood Park area during the period of the ranchos, the 1830s to the 1860s. The Chumash who once lived there had been absorbed into the life of Mission San Luis Obispo or had moved away. Los Osos Valley, east of the town-to-be, was prosperous and green with farms and dairy cattle. The only inhabitants left in the dusty sand hills closer to the bay were deer, rabbits, and coyotes, the famous grizzly bears having long ago been decimated. The vegetation, California poppies, lupine, oaks, and toyon, were food and habitat for the wild animals. The hills were cut through by Los Osos Creek, where willows, crimson sage, and poison oak grew. There was only a rough, dusty road between Hazard's and Spooner's land, once the old Rancho Pecho y Islay, for the four-hour trip from the coast to San Luis Obispo, which now takes 20 minutes by car.

In 1889, speculators arrived who laid out an imagined town of El Moro on a map; the 3,000-lot plan eventually was doomed by the lack of a bridge necessary for the railroad that never materialized. The project was abandoned in 1894. Nothing is known about residents who may have inhabited the few abandoned buildings left behind on Second Street.

Walter Redfield came to the area in 1919. There are several stories about his discovery of El Moro, but all agree that he saw the land, decided to invest, and eventually sold lots from his office in Los Angeles. He bought 340 acres of eucalyptus and subdivided 50 to 60 acres into Redfield Woods. He bought Charles Farrell's ranch and called it Sweet Springs. Richard Otto was the next large developer, purchasing the 3,000 grid lots from Redfield and beginning development in 1924. He changed the name to Baywood Park to distinguish it from Morro Bay. I.L. Mitchell optioned John and Maggie McGinnis's dairy farm below Redfield Woods and laid out Cuesta-by-the-Sea but left its sales to Arthur E. Coleman.

The natural beauty, resources, and peacefulness of the area, aggressive salesmanship, and people's willingness to take a chance brought Baywood Park to life, with Los Osos following later.

This view of most of lot 79 of the old Cañada de Los Osos Rancho, the largest such block, is close to what Walter Redfield and Richard Otto would have seen in the 1920s. The sand spit, the eucalyptus groves, and some row crops are visible. Morro Rock's north side has not yet been

closed off. The Morro Bay Oil Company still owned land here in 1924. Much of the property was owned by people who did not live here but in the city of San Luis Obispo. Lots not in El Moro proper were sold off, sometimes in large blocks. (Courtesy of Dean Sullivan, Sullivan Studios.)

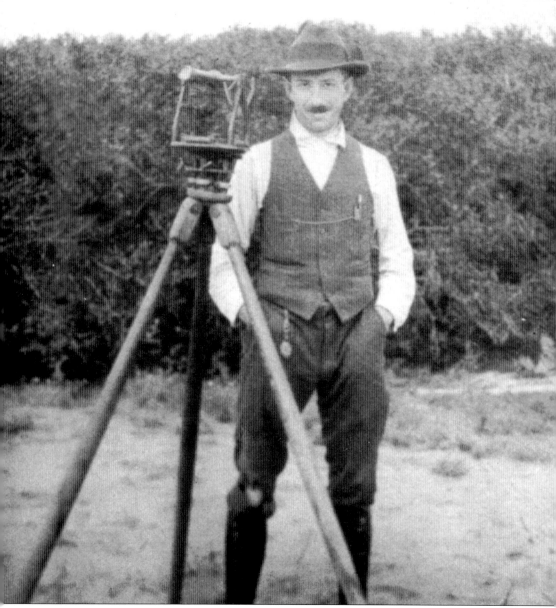

Walter Starr Redfield was the visionary who rekindled interest in creating the town of El Moro on sand hills. He worked for E.G. Lewis, the developer of Atascadero, but left that job to implement his plans for the 3,000 lots that he bought for $1 each. He is known for driving prospective customers in his 13-passenger stagecoach Cadillac from Taft and Bakersfield to El Moro for fishing, hunting, and swimming; putting them up in his tent city at the junction of Los Osos Valley Road and Pecho Road; and for giving them a sales pitch for buying lots. His wife, Pansy, cooked and managed. They lost much of their property during the Depression but later got it back. Redfield sold his last parcel around 1969. He and Pansy left Los Osos for good in 1979 when their second home, on the old El Moro hotel site, was condemned for the building of Baywood Elementary School. He died in 1987 at the age of 103. (Courtesy of the History Center of San Luis Obispo County.)

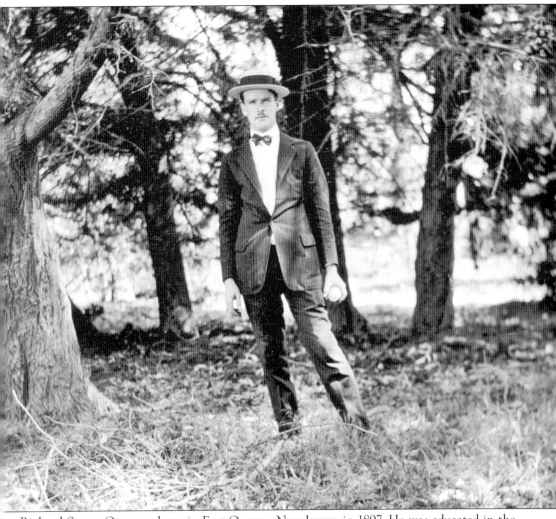

Richard Stuart Otto was born in East Orange, New Jersey, in 1897. He was educated in the United States and Europe. He did early engineering for the famous Norden bombsight, which became a valuable Allied secret during World War II. He managed Upton Sinclair's famous but unsuccessful campaign for governor in 1934 and ran unsuccessfully for state senator in 1940. He once spent a month in the court of a Chinese warlord on a loan negotiation. Otto bought his first 10 lots from Walter Redfield; he then bought 1,000 acres and began development in earnest in 1924. Otto died in 1966 at age 68 in Santa Barbara. Otto and his wife, Shirley, lived in Baywood Park for only 15 years, but he left an enduring legacy: the Monterey pines and cypress trees that still line the streets were among the thousands of seedlings he planted. That he extraordinarily flew his own plane into town, landing on Eleventh Street and taxiing down to the waterfront, has been mostly forgotten. (Courtesy of Dean Sullivan, Sullivan Studios.)

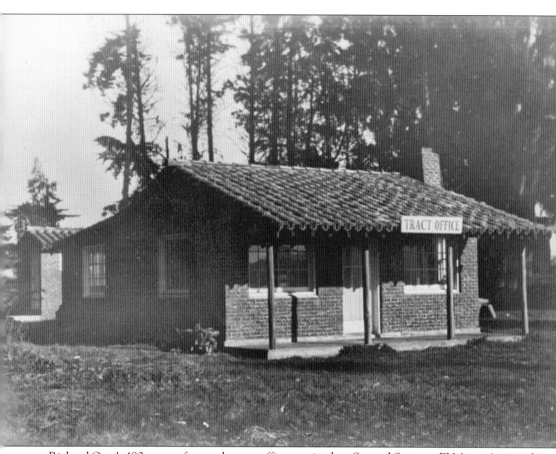

Richard Otto's 480-square-foot real estate office survived on Second Street at El Morro Avenue for 30 years. Otto also sold lots from his Hollywood office. In 1983, the building was demolished in front of anguished local history activists. Construction on the planned two-story commercial retail office space was sporadic and never completed. In 1987, the delinquent property was auctioned off. The Baywood Inn occupies the land now. (Courtesy of Dean Sullivan, Sullivan Studios.)

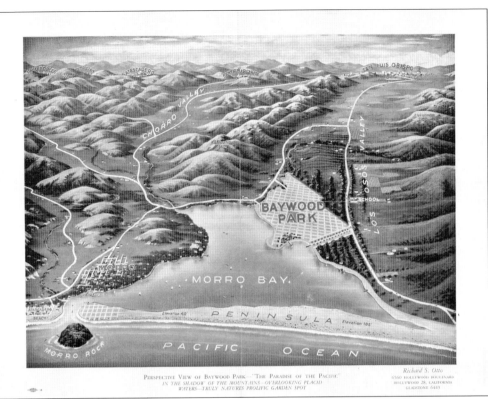

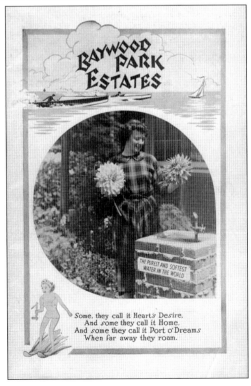

In the early 20th century, there was no auto access into Baywood Park, so lots were sold via other tactics. In the 1920s, advertising was key to selling lots in an area not accessible by any public transportation; much of that was done in California's Central Valley and Los Angeles, the most likely markets for sales. The above image was a color sheet for Richard Otto's advertising. Below is the cover to an accompanying brochure. Los Osos did not yet exist as a town. Dating the map, note that the causeway closing off the south entrance to the Morro Bay at Morro Rock wasn't constructed until 1933, and in 1928, the bridge shown as a road crossing over the creek flowing into the bay was not yet built. Otto also placed text-only ads in national publications like *Popular Mechanics* magazine. (Above, courtesy of San Luis Obispo County Regional Photograph Collection, Special Collections and Archives, Cal Poly; right, courtesy of Jeanne Blagg.)

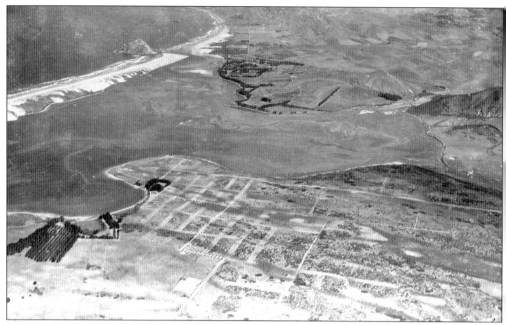

Morro Rock, at the top of this early photograph, was still an island. The grid toward the bottom is Baywood Park; Los Osos was yet to be built. Richard Otto's trees, which he planted after 1922, can be seen lining some of the streets. The cluster of trees left of center are on Second Street. The rows of eucalyptus at bottom left are off Pecho Road. (Courtesy of the Historical Society of Morro Bay/Juanita Tolle.)

A road from San Luis Obispo through Los Osos, bridging across the creek to Morro Bay, was proposed in 1928. Residents benefitted by the road were to be organized into an assessment district, but it was voted down. While not identified, this was a 16-foot oiled and graveled road in Los Osos; the pines were likely planted by Richard Otto, who planted and watered hundreds of trees. (Courtesy of Dean Sullivan, Sullivan Studios.)

Second Street in Baywood Park was just gravel in 1930. The boat pier can be seen, small and in the distance, but the boathouse was not yet built. Some of Richard Otto's little evergreens are on the right in this photograph. The tall trees were eucalyptus, a tree that commercially boomed, then busted, in California between 1870 and 1913. (Courtesy of the History Center of San Luis Obispo County.)

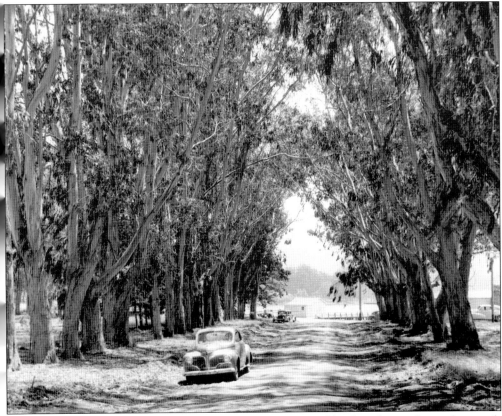

There were several local farmers who planted eucalyptus trees like these lining the road as a cash crop for railroad ties. But the wood didn't hold a spike securely and was prone to rotting. These ornamental eucalypti were removed in 1957 to widen the road. The stumps were burned with old tires to intensify the heat, sending coils of black smoke skyward. (Courtesy of Dean Sullivan, Sullivan Studios.)

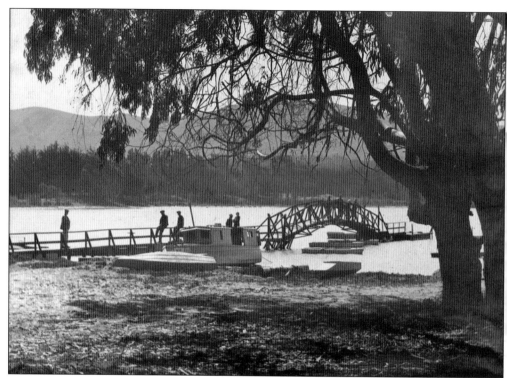

Sometime in the 1920s, Richard Otto built this 180-foot pier that had a floating dock at the end. Called the Duck Pier, it was used by hunters for their boats. The Army Corps of Engineers deemed it unstable and ordered it torn down in the early 1930s. (Courtesy of Alan Eto.)

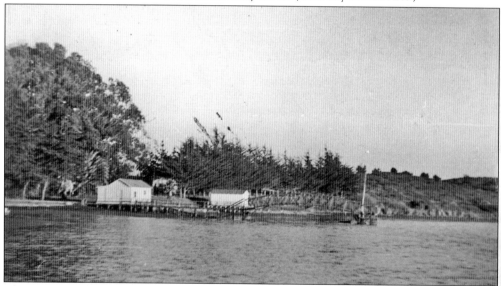

The Sail Inn is on the left and Spooner's small boathouse is on the right in this 1930 photograph. The Spooner it belonged to was not identified on the back of the photograph. Alden B. Spooner Jr. died in 1926. He had two other docking places that he used though, as it was easier to travel by water to Morro Bay than along the rutted road. One place was called McGinnis Point, the other Fairbank's Place (lots 1 and 2 of the old rancho). (Courtesy of Joan Sullivan.)

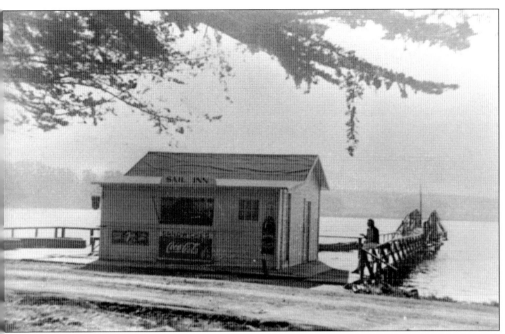

The Sail Inn boathouse at the end of Second Street was for the benefit of prospective lot buyers. They could rent boats and purchase sandwiches and cold drinks. The building was constructed in 1932 and sold to Ralph and Zelle Diefenderfer in 1933. They were lured from Lincoln, Nebraska, to California by reading one of Richard Otto's sales brochures. (Courtesy of Dean Sullivan, Sullivan Studios.)

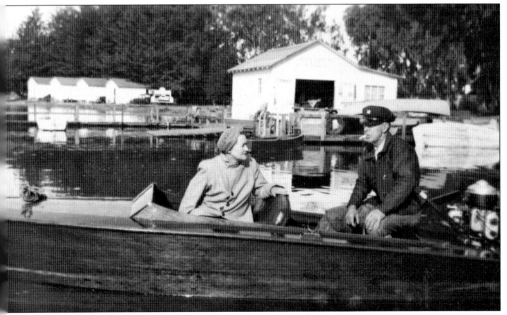

An unidentified couple sits on a small boat with the Sail Inn behind them and Otto's cabins in the background. In the 1940s, boats with a two-to-three-foot draft could come in if the tide was up. Rowboats could still manage when the tide was out. (Courtesy of Dean Sullivan, Sullivan Studios.)

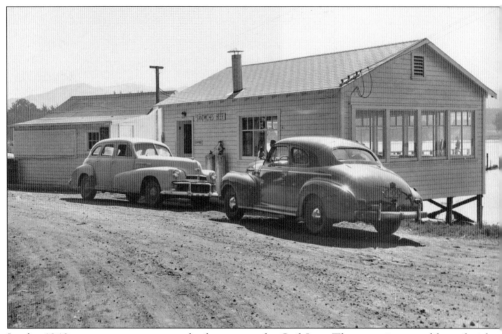

In the 1940s, a new structure was built next to the Sail Inn. The proprietors sold sandwiches and beer. The building later expanded and was called Gray's Baywood Fountain. Don and Fran Kitchen ran the restaurant, and Thelma Bailey was the postmistress and the first Baywood Park County Branch Library assistant. The building was moved in the 1950s to the middle of the block on the east side of Second Street. It was used as the office for Bruce Sikirk's lumber company. The women's club met there for a while. The pier was demolished. The building is now the Sculptured Egg, a breakfast and brunch place. (Above, courtesy of Dean Sullivan, Sullivan Studios; below courtesy of Tim Frein.)

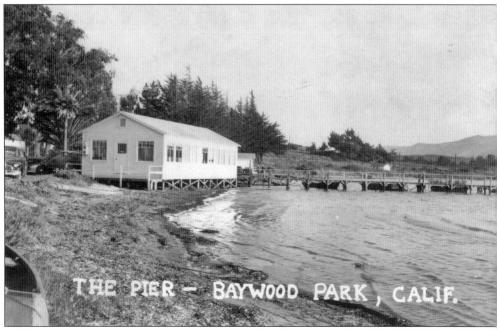

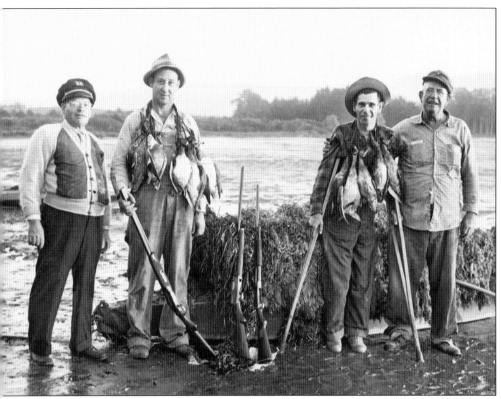

Standing by a duck blind boat in the bay mud at low tide are, from left to right, "Skipper" Robasciotti, Delcan Robasciotti, Emile Costa, and unidentified. Ducks and black brant were plentiful from the 1920s through the 1950s. The eucalyptus at Sweet Springs are behind them. Baywood's water supply, a well developed by Richard Otto in 1938, is on the left amongst the willows; it was shut down in 2015. (Courtesy of Dean Sullivan, Sullivan Studios.)

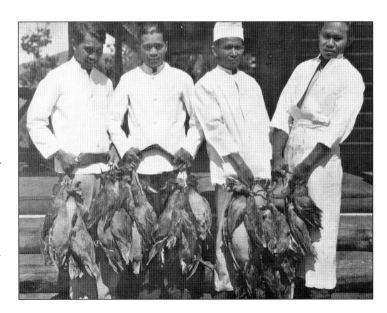

Work programs during the Depression era brought Filipinos to America, as the Philippine Islands had been annexed from Spain after the Spanish-American War and the Philippine-American War. These men worked at the Duck Inn, which is hidden in the eucalyptus trees behind the duck hunters in the photograph above. (Courtesy of Alan Eto.)

The four cabins and grocery store above were built by Richard Otto in 1940. They were rented to vacationers, bird hunters, fishermen, and prospective lot buyers by the day, week, or month. Walter Redfield accommodated weekenders in his tent city off Pecho Road. Three of these cottages were removed to El Morro Avenue and Third Street and seamed together into a house. Giltner's Cottages below were farther north on Second Street and were also rented to vacationers. They remain in place today as rental houses. (Both, courtesy of Dean Sullivan, Sullivan Studios.)

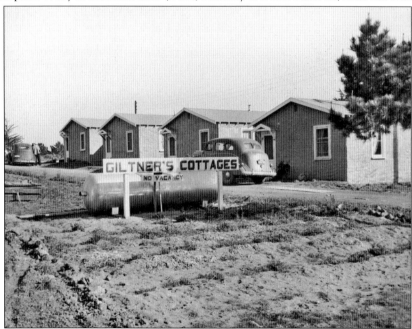

The photograph above shows the original hardware store built in 1953 at 1205 Second Street. It was the fourth home for the library, counting the unofficial library in someone's house farther north on the street. The fence on the right was removed and the building expanded, as seen below. Sandal Makara had his studio in the hardware store in the 1960s. Boot & Spur (center, below) occupied one of three buildings on the corners of Second Street and Santa Maria Avenue, all designed alike by Neil Wright. This bar was the town's first. Cowboys rode their horses to pick up beer. Hunters brought their kill into the bar to keep it from the mountain lions, coyotes, and foxes while they imbibed inside. (Both, courtesy of Dean Sullivan, Sullivan Studios.)

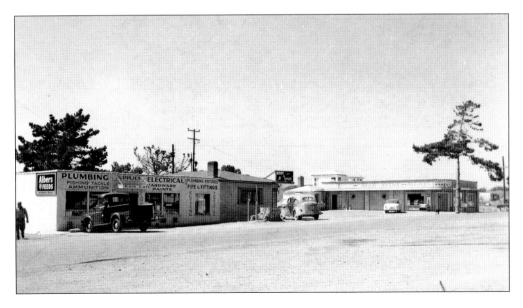

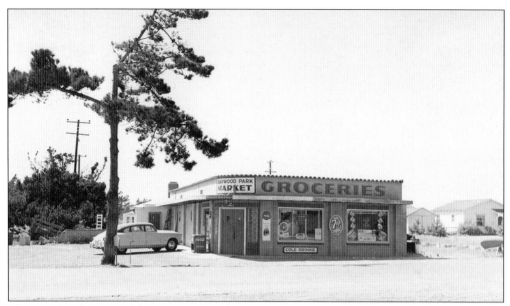

Neil Wright, designer of the Baywood Market's curved entryway of glass block, put his last name and the building's date above the door. The side has ship-like porthole windows. The triplet buildings were commissioned in 1947 by Richard Otto. This one was used over the years primarily to sell groceries and later alcoholic beverages but also served as a second-hand store. (Courtesy of Dean Sullivan, Sullivan Studios.)

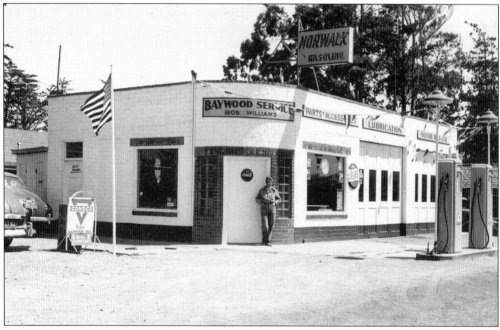

The Baywood Park Service Station was another of the Neil Wright buildings. After Richard Otto, the next owner, William Oertle, sold it to Bob and Maye Williams. Maye Williams is pictured in 1953 in her work uniform. Years later, with the gas pump removed, the main office and garage repair bays were converted into separate businesses. This building was demolished in 2009. (Courtesy of Dean Sullivan, Sullivan Studios.)

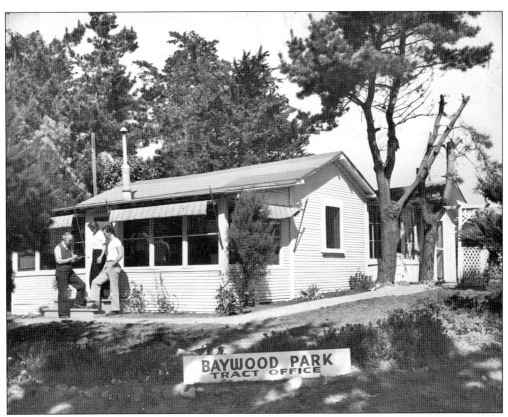

There were several developers selling property in Baywood Park. This office, once the house made of Richard Otto's bayside cottages, is now a sales office, but it appears in Richard Otto's 32-page sales brochure as "A cosy home in Baywood Park Estates." It is still located on El Morro Avenue between Second and Third Streets and is a cottage rental for the Back Bay Inn. (Courtesy of Dean Sullivan, Sullivan Studios.)

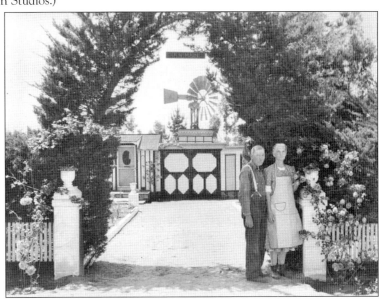

In 1931, Albert Main bought lots 15, 16, and 34 in block 138 in Baywood Park from Richard Otto. In 1931, Main was reported to make an addition to his Twelfth Street house, and in 1933, he built a cabin. He married Diana Ogardh in 1937. (Courtesy of Dean Sullivan, Sullivan Studios.)

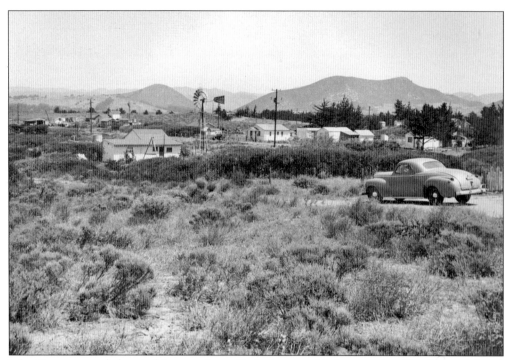

John Rogers, seen below in his powerboat, likely drove to his house using Pine Street (above) from his office in San Luis Obispo. Rogers was the man who sounded the bay and placed the pole markers. He moved and maintained them for over 30 years as the channels meandered over time with sedimentation. He offered a great service, especially to vacationers who did not know the waters. It was easy to get a boat stuck in the black, gooey mud at low tide, and it was a long, hard slog out and back to shore. Rogers's public service also included work as a uniformed civilian night guard at the Camp San Luis arsenal during World War II. For over 50 years, he gained fame as a dowser, locating water well sites all over the county, including for the California Division of Highways to replace wells eliminated by highway construction. (Above, courtesy of Dean Sullivan, Sullivan Studios; below, courtesy of Roxana Rogers Lopez.)

John Lawrence Rogers, one of the first to purchase a lot in Cuesta-by-the-Sea, owned a radio shop in San Luis Obispo that sold radios shipped in large wooden crates. With a carpenter friend, he built the first house in this area out of those crates, a clever combination of thrift and ingenuity. It is one of the rare original homes still used today. (Courtesy of Roxana Rogers Lopez.)

Alice and John Rogers stand in front of the garden at their Cuesta-by-the-Sea home. Alice initially refused to move into the house without telephone service. But John quickly got permission from PT&T, the region's telephone company, to string his own wire up to the connection box at Los Osos Valley Road through Walter Redfield's woods. (Courtesy of Roxana Rogers Lopez.)

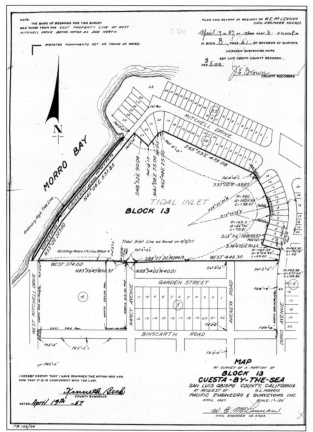

Cuesta Inlet is one of the few intertidal areas in California that is privately owned. The 1957 survey map at left shows the original shape of the inlet. When the tide was out, fish trapped behind the causeway were easy to catch. In 1960, the Morro Keys Company intended to build a Florida-type subdivision by raising 40 acres of submerged land to create 168 waterfront homes with private docks. Some dredging was done to create the shape it is today, but the project was stopped. The small lots along the inlet and bay were lived on while waiting to build houses, as in the photograph below, and small shacks were converted into homes. The building moratorium in 1988 due to groundwater contamination kept anything more from being built. (Left, courtesy of San Luis Obispo County, County Surveyor; below, courtesy of Gary Karner.)

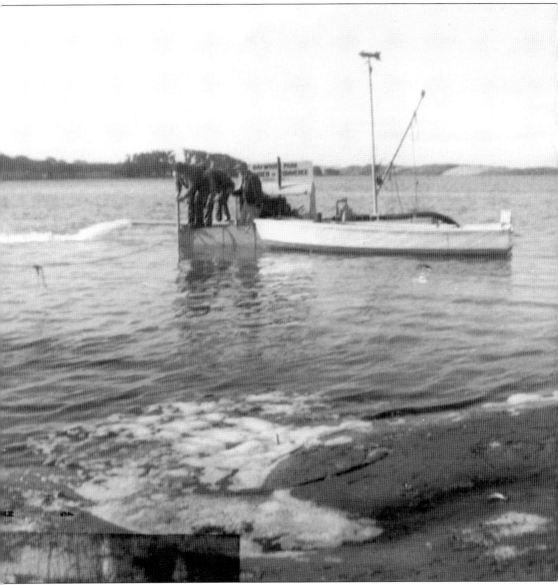

The piers at Second Street could no longer be built far enough out into the bay to be useful. The bay had silted in alarmingly since Morro Rock's northern passage had been closed off. In 1957, Art Druit and Capt. Ralph McCoy built a dredge boat, with Joe Sheridan installing the engine and pump. This was a Baywood Park Chamber of Commerce project, and Richard Otto was the president. Controversy ensued as Ernest Vollmer, an early owner of lot 79, claimed ownership of the submerged lands. But he had only the mineral rights to possible oil reserves. The men continued dredging for three to four months; the project was hopeless. This ownership issue surfaced again in 1983 from the Morro Bay and Land Company while the old 1955 pier (see page 117) was rebuilt. (Courtesy of Tim Frein.)

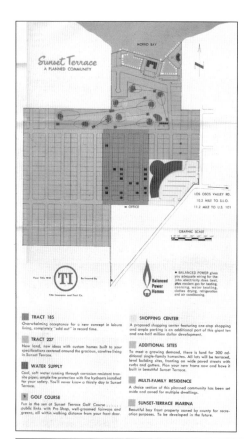

Sunset Terrace was a housing development planned in the 1960s. It included a nine-hole executive golf course that third-generation native Ed Peterson helped to lay out in the late 1950s. Sunset Terrace was developed on the Tauxe property and managed by Blackie and Jack Holland. Longtime Clark Valley resident James Beecham cleared the eucalyptus trees to build the homes. The golf idea was Walter Redfield's first. He laid out a course and planted grass, but without water, it died. The $54,000 irrigation cost cancelled his project. (Left, courtesy of Jeanne Blagg; below, photograph by Sophus A. Dalager, courtesy of Craig Beecham.)

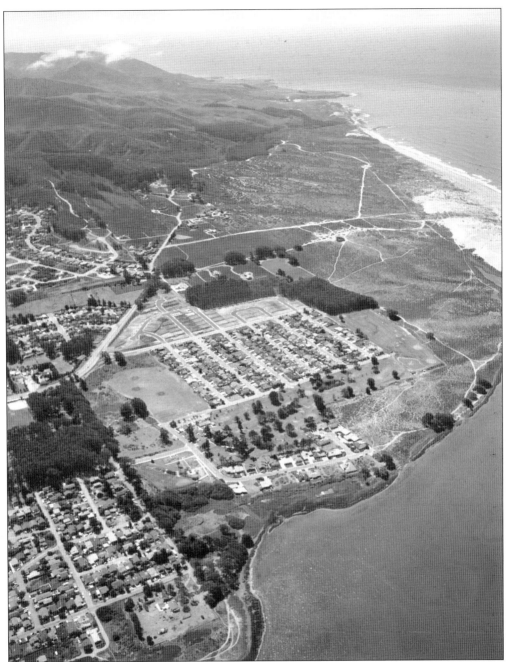

Not all of Sunset Terrace was built. The land was scraped and the eucalyptus logs burned in a large pit with old tires as an accelerant. Part of the vacant land seen here became a driving range. But the marina was cancelled for environmental reasons. Beyond the built homes are the vacant lots of the to-be-built Monarch Grove development. The trees above and to the left of the lots were saved when the developer took out acres of trees without a permit, and the remaining trees were set aside for a monarch butterfly refuge. Today, Sunset Terrace has the Sea Pines hotel, a pro shop, and a restaurant. Other developments visible to the left are Vista de Oro across from the vacant land, and Cabrillo Estates just above that. (Courtesy of Gary Setting.)

Richard Otto's Baywood Lodge Restaurant opened in 1953. The lodge itself was across the street; it replaced the four small cabins. A six-unit second story had been added by Joe Sheridan, and rooms with or without kitchens were available. In 1957, a stove in the restaurant was left on, and propane leaked into the kitchen and ignited. The roof was lifted by two feet and the kitchen was destroyed. The building was repaired and hosted other restaurants over the years, including the Salty Pelican, Papillon, Mare Blu, and La Palapa. (Above, courtesy of Dean Sullivan, Sullivan Studios; below, courtesy of Joan Sullivan.)

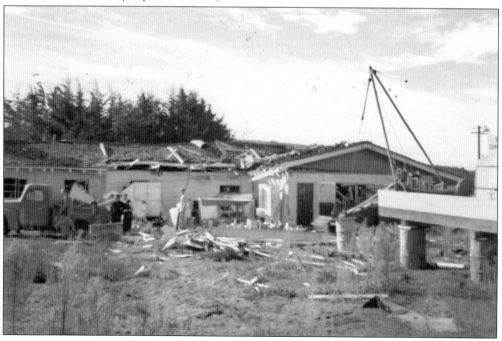

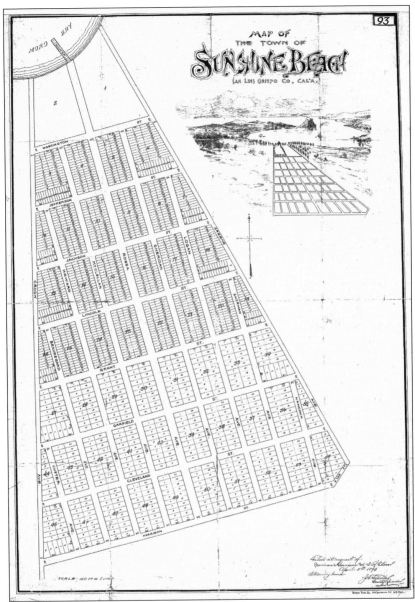

While the 1889 speculators of the town of El Moro lost money, developers Walter Redfield and Richard Otto were spectacularly successful in marketing and growing Baywood Park, weathering even the Depression. The population went from a few souls in 1919 to 600 by 1950. Lesser known but just as profoundly unsuccessful as the 1889 El Moro development was Sunshine Beach, the pie-shaped property wedged between El Moro and Cuesta-by-the-Sea. A park (the present Sweet Springs Nature Preserve) was included in the plan proposed by Norman Harrison and D.R. Oliver in 1893. The development was never registered, and the lots were never filed as separate, legal lots. The property of Sunshine Beach was owned by a succession of people. It is presently called the Morro Shores area, and a part of this was purchased for the failed 2005 sewer project. Morro Shores Mobile Home Park, the community center within the Los Osos Park, the library, a church, and homes are there today; some unbuilt land remains. (Courtesy of San Luis Obispo County, County Surveyor.)

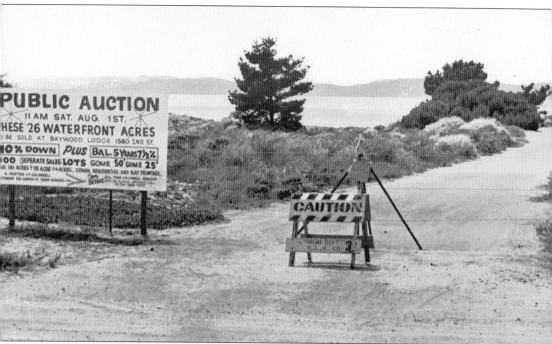

Richard and Shirley Otto left Los Osos in 1964. Richard Otto died in 1966, and an auction was held in 1970 to clear his estate. The auction lasted five hours and included a five-year-old Rolls Royce that sold for $5,300. The sale listed almost 300 acres, plus 26 additional acres west of First Street on Pasadena Drive with access to the bay. These streets to the bay were blockaded with a barbed-wire fence, upsetting the public, which had not known this was private land. This area had been designated a park by the Morro Bay Improvement Company in 1895. When the streets were built, they were offered to the county, but it was unclear if they had been accepted, as they were not on the road maintenance list. The large parcels of land were broken down to about five acres each and went from $5,000 to $34,000, depending on location. Shirley Otto held onto the land that later became the Elfin Forest. (© the *Tribune*.)

Four
Los Osos, at Long Last

There was no town of Los Osos until the 1950s. Baywood Park and residential Cuesta-by-the-Sea had been growing down along the bay since the 1920s, but they were geared primarily for vacationers and retirees. Los Osos was really just a nameless spot on a rutted dirt road with Charles and Emma Ferrell's tiny mom-and-pop grocery store and gas pump in the late 1920s. There was a farm or two, but not like the farming that went on to the east in the valley. Where Los Osos' "downtown" would someday be, there was just a flatish spot on a hill. The 1875 schoolhouse in the area was built for the ranch children from as far away as Spooner's place in what became Montaña de Oro. It was called Sand Hill, which described it well. It was there before the thought of a town.

It was not until the 1950s that anything that could be called civilization started to grow. By 1952, there were 13 widely spaced small buildings between Sunset Drive and Bush Avenue on Los Osos Valley Road; there were four real estate offices, three gas stations, a lumber yard, a café, two homes, Walter Lambert's water company, and Ferrell's, although Ferrell's was not there then. They sold when Prohibition was over, as they did not want to sell liquor to stay in business.

The realtor of the moment, developing areas both north and south of Los Osos Valley Road, was Ralph Robert Westfall. He took over what was Redfield's or Reiger's Woods and called it Los Osos Highlands (that name still exists on part of it; it was in the old Call Tract), and the other side of Los Osos Valley Road would be Vista Del Morro (formerly the Slack Tract). Most street names there still exist, except Reiger Avenue, which became Doris Avenue, and poor Clelland Avenue, while on maps of the day, did not last as a road. Westfall boasted of red rock roads into the development, a new water system, and homes on sale for as little as $3,750.

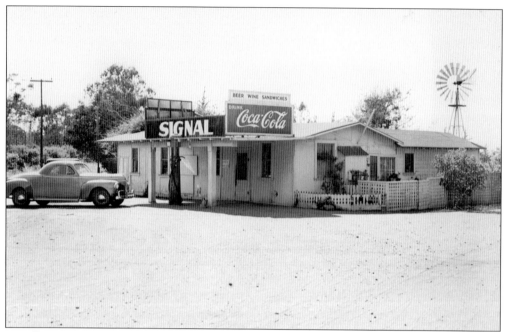

Ferrell's store at Ninth Street and Los Osos Valley Road was built in the late 1920s by Charles and Emma Ferrell. It was the first gas station and grocery store in Los Osos Valley. They served sandwiches, chili for a dime, and coffee for a nickel. The building was later called Paul's Corner, run by Paul Moribito, then Frogs. Now it lives on as the Sweet Springs Saloon. (Courtesy of Dean Sullivan, Sullivan Studios.)

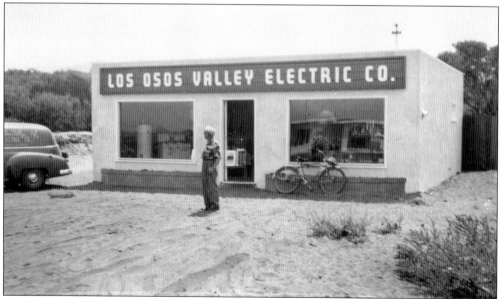

The Los Osos Valley Electric Company started in the spring of 1953 and was owned by Eugene S. Lambert. The building was located on what was then called Los Osos Road and Tenth Street. They sold televisions, ranges, heaters, washers, and small appliances. The building later became a real estate office. There were four offices along Los Osos Road in the mid-1950s. (Courtesy of Alice Kolb.)

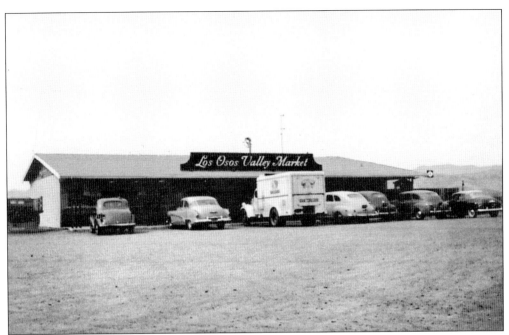

The Los Osos Valley Market was called Carp's by the locals. It was built by Everett Carpenter and run by his wife, Virginia. Deer heads decorated the walls. Curley Fry was a popular employee. This area was called Vista Del Morro by developer Robert Westfall. The building was later expanded to house Bay Osos Hardware and Carlock's Bakery. (Courtesy of Alice Kolb.)

The wing perpendicular to Carp's Market was built in 1965. Some of the businesses that came and went were Ruby & Roscoe's Upholstery Shop, Dr. Thumma's office, Harry Harvard's Insurance, Roy and Stuart's Barber Shop, Bay Osos Realty (started by Henry Bumpus, Gilbert Keas, and Dave Wagner), and the post office. (Courtesy of Alice Kolb.)

The white portion of this building (next to the Tenth Street water tank in the background) was built in 1958–1959 as a temporary home for the Burge family while their house was being built. The brick portion was added later. Over the early years, the building complex had a hardware store, the Country Inn Malt Shop, Village Inn Dinner House, a water company, and a mortuary. (Courtesy of Jeanne Blagg.)

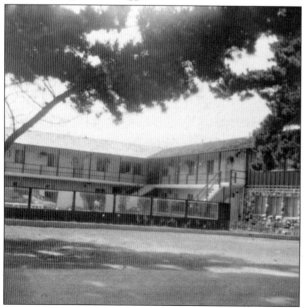

A variance was granted for the corner or Ninth Street and Nipomo Avenue so that a 24-unit motel could be built in 1959–1960. The Blue Heron Motel featured a rare, luxury item for the area: a swimming pool. That has since been filled in, and the building was converted to apartments. Vestiges of the rim of the pool can be seen amidst the plants that now fill it. (Courtesy of Alice Kolb.)

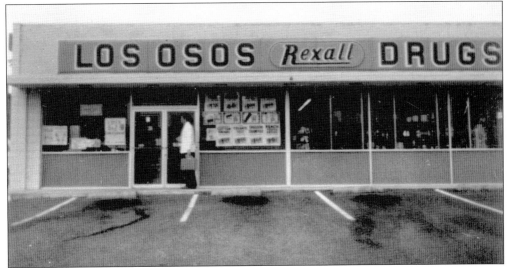

Pharmacist Bud Witsch owned the Los Osos Rexall drugstore that was at the corner of Santa Ysabel Avenue and Second Street in Baywood Park. Jones and Carpenter bought a lot and built by the new Sunnyside School, and Witsch moved the Rexall there in 1962. Gary and Judy Tewell bought the Rexall from Witsch and the building from Jones. The Tewells are still there today. (Courtesy of Judy Tewell.)

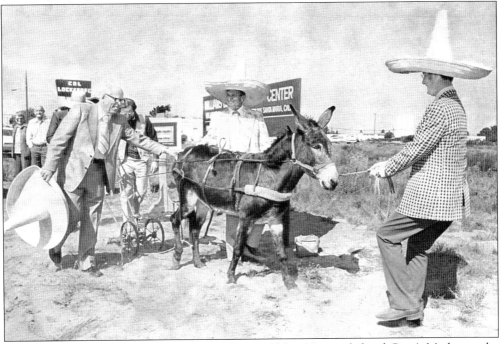

The estate of Los Osos resident Sophus Dalager sold his 13 acres behind Carp's Market to the Williams brothers. The brothers had a chain of central coast grocery stores, and were expanding to Los Osos. The ground-breaking ceremony was held in October 1977. From left to right are county supervisor Milton Willeford (holding the hat); Merle Williams; and Jim Sims, president of the Los Osos/Baywood Park Chamber of Commerce, leading a burro pulling a miniature plow. (Courtesy of Robin Sims.)

Sunny Side School, the one-room building pictured on the left, was built in 1875 and remained operational for 79 years. It was originally called Sand Hill School. It was built by rancher/farmer John D. Peterson, who donated the land because his daughter needed a school to attend. Schools were built locally, as travel was very difficult for students. (Courtesy of the History Center of San Luis Obispo County.)

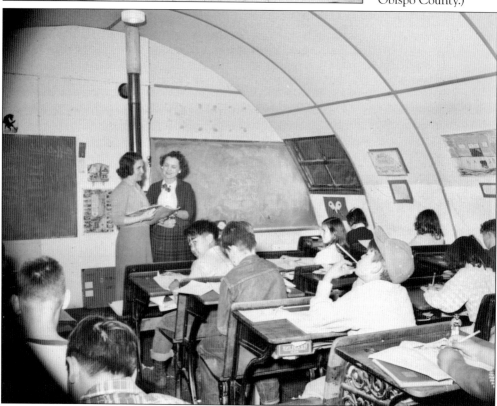

Sunny Side School had so many pupils that an auxiliary classroom was needed. The solution was an old World War II Quonset hut until the new school could be ready for fall of 1955. The contract for five classrooms and an administration office was let to Maino Construction for $79,637. It would be built on the former property of Dr. Harold N. Broderson of Los Angeles. W.D. Holdridge was the architect. (Courtesy of the History Center of San Luis Obispo County.)

Boys in the 1950s would comb the area around the sand dunes where the military had practiced during World War II. From left to right, Mike Sheridan, Pat Sheridan, Jim Sheridan, and Rod Smith pose with unexploded ordnance they found. They stand on Fifth Street with Dean Cottle's realty office in the background. The area has been cleaned twice by companies contracted by the military, but shifting sand will sometimes reveal more artifacts. (Courtesy of Tim Frein.)

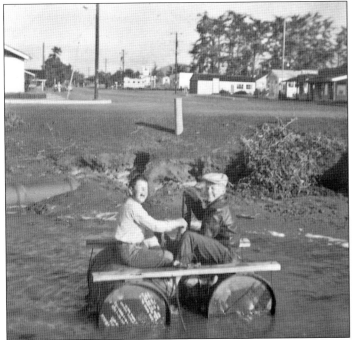

Jim (left) and Pat Sheridan play in the bay on their oil drum boat in 1954. The Second Street buildings behind them are, on the left, the Baywood Park Grocery, and, across the street from right to left, the Baywood Lodge Restaurant, Gray's Baywood Fountain (now moved off of the pier), an unidentified building, the Williams's gas station, and an unknown building in front of Giltner's Cottages. (Courtesy of Tim Frein.)

Beach buggies were the best way to drive over to the dunes to go clamming or fishing. Families would spend the weekend there building driftwood fires to cook the clams, oysters, and fish. The limit was 10 clams per person, and they had to measure four and a half inches in diameter. The clams and buggies are both gone now. (Courtesy of Jeanne Blagg.)

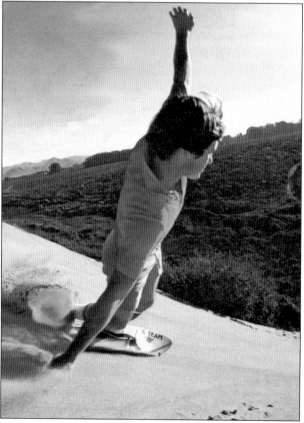

People were sliding down the dunes at least as early at the 1950s. Gary Fluitt and Jack Smith popularized the sport in the 1980s by inventing sandboards that would allow a person to twist and jump in the air. Sandboarding is now an international sport. (Courtesy of Jack Smith.)

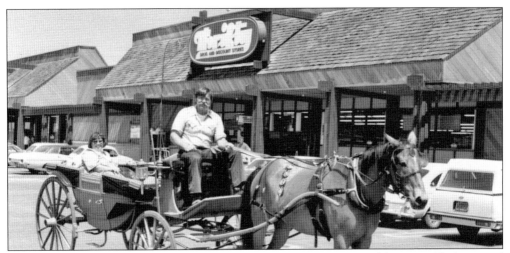

In the 1970s, the traffic was so light that John and Jean Lindemans were able to travel by horse and carriage. Jean "Mama Bear" Lindemans was the 1988 San Luis Coastal Unified School District's Teacher of the Year. She established the parent volunteer program at Sunnyside School and its insignia, and at Baywood Elementary School she created the Baywood Bear. She was much loved by the whole community. (Courtesy of Johanna Sanders.)

Barbi and Dick Breen are delivering Christmas presents with dogs Cinnamon and Thoressa and horse Comet in the early 1970s. The Sweet Springs Saloon is behind the horse, and the Jiffy Food Store is behind the stop sign; in the 1960s, it was Rosie's Convenience Store. Dave Wagner also drove around town in a carriage, selling lots for Bay Osos Realty. (Courtesy of Barbi Breen-Gurley.)

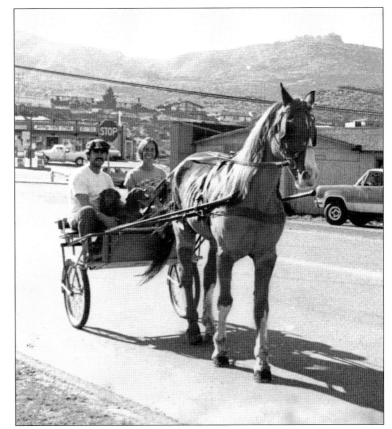

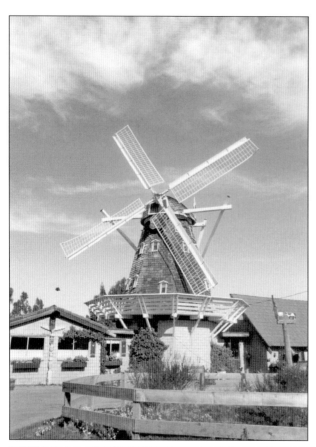

Once visible but now hidden by trees is contractor John Lindemans's tribute to his Dutch roots, the Windmill House. It was built in the style of a smock mill, which in Holland would be built where there was unstable soil, like Los Osos' sand dunes. This was the family home on 10 acres. Lindemans also ran a carriage-for-hire business, catering to weddings and other special events. (Courtesy of Johanna Sanders.)

One of Walter and Pansy Redfield's houses (located at Los Osos Valley Nursery) is said to be haunted by a ghost wearing blue jeans, a Pendleton shirt, and a beige, large-brimmed hat. Speculation as to who it could be includes Horatio "Papa" Warden, who lived in the house from 1942 to 1964, or perhaps a guest of the Redfields. (Courtesy of Hope Merkle.)

Five

COMMUNITY

Los Osos/Baywood Park, off the beaten path and isolated by a shallow bay and rutted roads in the early days, was a community relying on help from within when needs arose. What stores existed were stocked with the basics, and the larger, infrequent shopping expeditions were into San Luis Obispo or across the wooden bridge at the end of Santa Ysabel Avenue, over to Turri Road, and around the estuary to get to Morro Bay. But early on, there wasn't much there either.

When Baywood Park had a lucky infusion of self-reliant women, the new women's club in the 1950s guided, strengthened, forged, and ignited a community spirit through the shared goals of making a meeting place and just having fun. The events that they held were numerous, and many of them included food, always a good community bonding experience. Their importance to building community should not be understated. There was such a plethora of groups that it is hard to understand how they could find members who were not committed elsewhere. To name a few, there was the Grandmother's Club, the Bay-Osos Lions and Lionesses Clubs, the Arts and Crafts Festival Club, and the South Bay Garden and Improvement Society. Business groups and groups that advised the county existed too: the South Bay Advisory Committee, the South Bay Civic Association, and the Baywood Downtown Association.

Gone are many of the community events even from recent times: the Fun Runs, June Fest, the Press on Regardless boat races, and Pedal, Paddle, Plod. The old dance hall at First Street and Pasadena Drive is gone, too. People Helping People still exists and has grown. Oktoberfest gets bigger every year. The Baywood Navy continues. The business community is gaining ground and getting savvier on how to survive in a bedroom community where most people work out of town. The sewer battle has had a dampening effect on community. With that infrastructure almost done, it remains to be seen if the idea of community starts emerging; not the way it was, but in some new way.

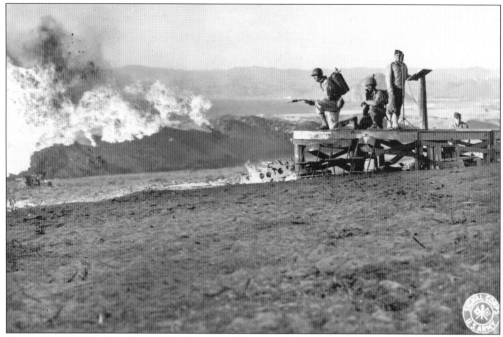

During World War II and into 1946, the sand dunes off of Baywood Park were used by the Army, Navy, and Marines for training exercises such as amphibious landings and an artillery practice range. Years later, 105-millimeter projectiles, five-inch rockets, rifle grenades, hand grenades, practice anti-tank mines, dynamite, and small arms were found. The area has been swept in the early 1950s, 1959, and 1994, but scuba divers have reported finding artifacts underwater after that. (Courtesy of the National World War II Museum.)

Army representatives honor fallen military comrades on Memorial Day at Los Osos Valley Memorial Park in 1960, when the park was founded. There have been Memorial Day commemorations there ever since, with the San Luis Obispo County Band, laying of the wreath ceremonies, and guest speakers. Representatives are from the Army, Navy, Air Force, Marines, Coast Guard, and the La Cuesta Chapter of the National Daughters of the American Revolution. (Courtesy of the Los Osos Memorial Park & Mortuary.)

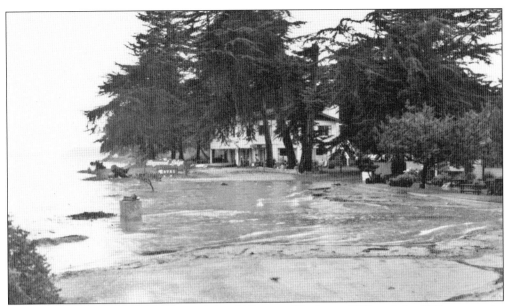

Storm water and a high tide threatened the old Baywood Lodge in 1983, and the 1955 community pier on Second Street was destroyed. The Baywood Park Chamber of Commerce and the Downtown Baywood Park Business Committee raised money across the town; local contractors and tradesmen donated their labor and equipment. The county waived fees and issued a building permit, and the pier was rebuilt. (Courtesy of Tim Frein.)

In 1983, after Richard Otto's famous office was demolished, citizens salvaged the bricks. They were moved behind the old Baywood Restaurant, at that time the Salty Pelican, and rebuilt into a community barbecue. (Courtesy of Bob Crizer.)

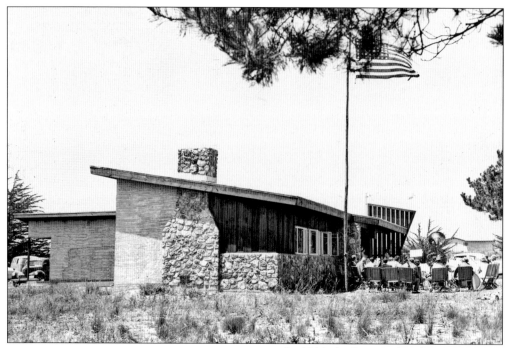

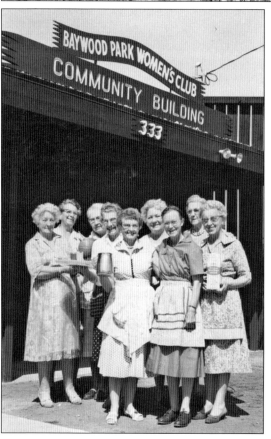

In 1944, the Baywood Park Women's Club began as a group called the Home Department Extension Service of the State of California. In the early 1950s, Susan Dadisman decided to just make it a women's club. In 1953, with $70 in the bank, the Baywood Park Women's Club became a legal, nonprofit organization. It put on yearly festivals and parades and held fundraisers with the aim of building a center where everyone could get together indoors for meetings and social events. By April 1956, land had been acquired. Architect Clinton Charles Ternstrom donated his services. The foundation was poured for the building. Colored rocks were provided for the fireplace by J.C. Tonini in Los Osos Valley. All the labor and much of the materials were donated. On May 31, 1957, the building was dedicated. Its location was 333 Seventh Street (now numbered 1337). Today, it is the home of the Los Osos Christian Fellowship Church. (Above, courtesy of the History Center of San Luis Obispo County; left, courtesy of Joan Sullivan.)

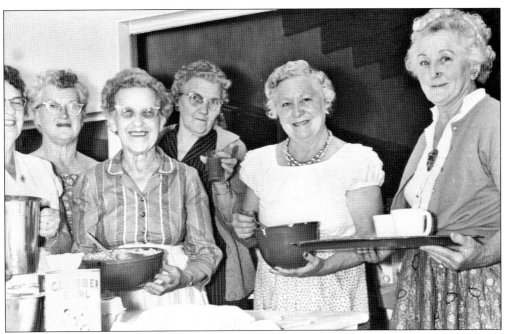

Women's Club members from around 1961–1962 are, from left to right, Hattie Rowell, Eleanor Thomas, Marie Lyman, Zelle Diefenderfer, Grace Ross, and Edel Stevens. The women raised money by holding breakfasts, rummage sales, card parties, dinners, and fashion shows. They let organizations such as the Girl Scouts, Boy Scouts, and the Well Baby Clinic use the building for free. (Courtesy of Joan Sullivan.)

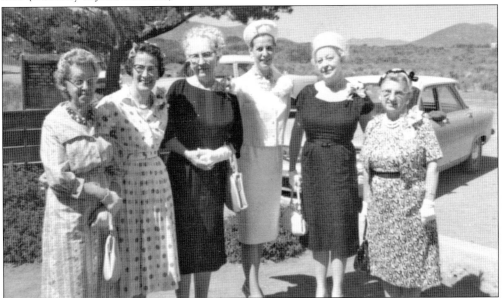

In 1990, the Women's Club lost its nonprofit status. The insurance went up, and rentals didn't cover costs. The club donated the building and the property to the Cuesta College Foundation, and $7,000 went to the South Bay Library Association and the Friends of the Library. Pictured here in 1962 are, from left to right, Marie Lyman, Maye Williams, Rotha Stockman, Dolly Tauxe, Eileen Thornbergson, and Ina Buck. (Courtesy of Joan Sullivan.)

Baywood Park Community Church was Los Osos' first church. There are two stories as to how this church began, but both agree that it was in 1944. The fledgling congregation met at the George Mahan house and at Sunny Side School. Mrs. Charles Ferrell and Mrs. Fred Bolton and a couple on Twelfth Street got the church organized. Church offerings, plus a donation from the Women's Club, paid for the first land purchase. Richard Otto donated a 50-by-125-foot lot, stipulating that the group must never affiliate with any particular denomination. The church basement was constructed first (above), and services were held there from 1947 until 1952, at which time the Army chapel from Camp Cook at Vandenberg Air Force Base had been obtained, disassembled, and reassembled over the basement. Otto used to land his plane along Eleventh Street where the church is located. (Both, courtesy of Baywood Park Community Church.)

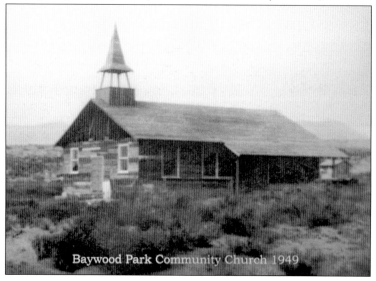

The Trinity United Methodist Church was organized in 1958. By December 1960, an A-frame building was consecrated and dedicated. There was a view of Morro Rock at the time. By 1975, the congregation had outgrown the church, and an innovative design for remodeling was drawn by architect Don Severa. The church was split in two, and one half was moved; a flat roof was placed between to join the two halves. Contractors John Lindemans and Evert Van Heeringen did the construction. This doubled the capacity. The carillon bells were donated by Mildred Pitt. (Both, courtesy of Trinity United Methodist Church.)

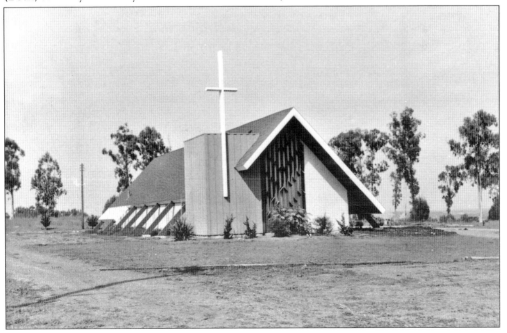

The Los Osos Church of Christ has been in San Luis Obispo County since 1961. It moved from Cayucos to Los Osos in 2004 when the congregation outgrew its building. Hurlen and Rena Merriman donated land so that a new, larger church could be built. The group met in the Sunny Side School and at the Los Osos Valley Mortuary Memorial Chapel while the church was being built. (Author's collection.)

The First Baptist Church of Los Osos began in 1974, meeting at the South Bay Community Center. The Southern Baptist Convention owned two-and-a-half acres on Lariat Drive and Los Osos Valley Road and convinced a nearby retired Camp San Luis Obispo chaplain to field a church. Aside from framing and drywall installation, all the work to build the church was done by volunteers. (Courtesy of the First Baptist Church of Los Osos.)

St. Elizabeth Ann Seton Parish formed in 1984. The flood of 1982–1983, which made access to Mission San Luis Obispo impossible, convinced the Los Osos parishioners that they needed their own church. Two acres of land was donated by Al Switzer, the vice president of the Morro Shores partnership. The congregation paid for a third acre. The congregation met for two years at the new Sunnyside School and at Trinity Methodist Church before building. Switzer had to construct a 400- to 500-foot extension to Palisades Avenue to allow access to the church. In 1986, the church was completed. (Both, courtesy of St. Elizabeth Ann Seton Parish.)

St. Benedict's Episcopal Church began in 1984 with a group meeting in people's homes for about six months. They met with St. Peter's Episcopal Church in Morro Bay, at Trinity Methodist Church, and at the Los Osos Valley Mortuary Memorial Chapel. In 1993, the Dioceses of El Camino Real purchased the property from the mortuary. Originally, the church was going to be built in the Spanish Mission style, but chapel No. 2016 from Camp Roberts, built in 1941, was chosen instead. It was moved from 50 miles away to Snowy Egret Lane in Los Osos. Watching the steeple lowered into place are Faith Watkins (right), who led the $3-million fundraising drive, and an unidentified friend. (Both, courtesy of St. Benedict's Episcopal Church.)

This late 1950s group would get together once a year to clean up trash around town. Participating in the Baywood Clean-Up Day are, from left to right, unidentified, Gilbert Kuramitsu, Leslie Tanner, Gene Tanner, Allyson Daley, unidentified, Bob Tauxe, Eleanor Thomas, and unidentified. (Courtesy of Joan Sullivan.)

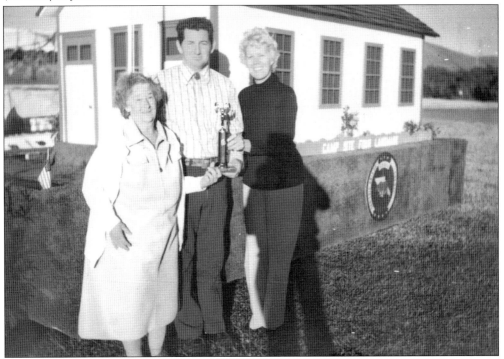

From left to right, Isabelle "Granny" Orr, John Locke, and Joan Sullivan are standing in front of the May 20, 1972, entry into the La Fiesta parade in San Luis Obispo, "Two Centuries to Tomorrow 1772–1972." This Los Osos schoolhouse float won a trophy. The replica of the 100-year-old building was constructed by the La Cañada de Los Osos Bicentennial Committee. The La Fiesta parade was held almost continuously from 1925 to 1995. (Courtesy of Joan Sullivan.)

In 1963, a new Los Osos Baywood Park Community Chamber of Commerce was formed. It stated that this would in no way affect the older Baywood Park Chamber of Commerce. In 1974, the officers of the Baywood Park Chamber of Commerce were installed with the congratulations of supervisor Elston Kidwell (center, black jacket). From left to right are Lew Richmond, Bea Richmond, Roger Himovitz, Victor Brunelli, Elston Kidwell, Linda Brown, Marie Boulware, Louis Cosentino, Harry Harvard, and John Sharp. The two finally became the Los Osos/Baywood Park Chamber of Commerce at a now forgotten date. (Courtesy of Los Osos/Baywood Park Chamber of Commerce.)

Los Osos/Baywood Park's Filipino community is participating in Make A Difference Day in 1996 or 1997. This is a nationwide single-day volunteer event to work on public service projects. (Courtesy of Albert Calizo.)

The Bay-Osos Filipino Community Organization, pictured here, was formed in 1987 to help one another with new immigrant assimilation, teach children English while maintaining native dialects, provide scholarships for kids to continue their college education, and help with funeral expenses. There are about 120 Filipino families in Los Osos/Baywood Park. (Courtesy of Albert Calizo.)

Senior citizens wanted their own center in the 1970s. The People Helping People group was given county land and began raising money. In 1983, state park lands grant money was obtained through the county board of supervisors. Architect Tom Courtney drew plans, and in 1984, serious fundraising began. The Bay-Osos Lions Club, Tammy Cady, and the will of Henry Bumpus contributed. The building was completed in 1986. (Courtesy of Bob Crizer.)

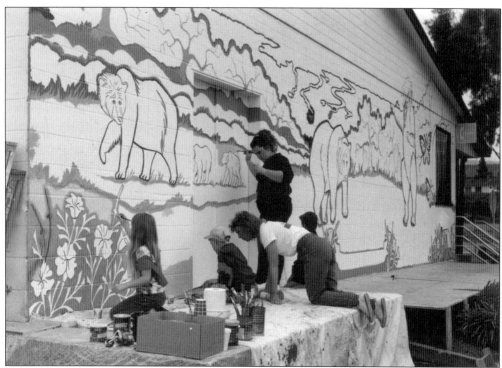

The Cañada de Los Osos mural at Los Osos Valley Road and Tenth Street was first mentioned to the public during the Festival of the Bears in 1989. George Kastner, chairperson of Los Osos/Baywood Park Chamber of Commerce Business Improvement Committee, organized Bringing Back the Bears; anyone willing to pay $5 to paint a section of the mural could do so. The mural was designed by Janice Sharman-Hand and was on the side of a store called the Strawberry Patch Ice Cream Parlor. Its purpose was to grow community: it takes many individuals working together to get anything done. (Both, courtesy of Janice Sharman-Hand.)

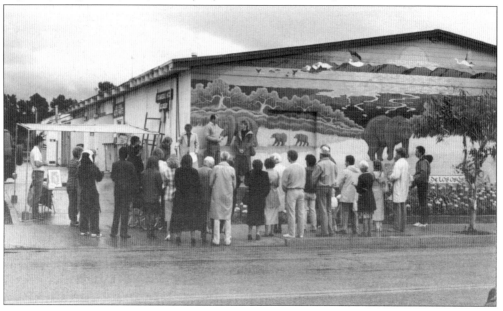

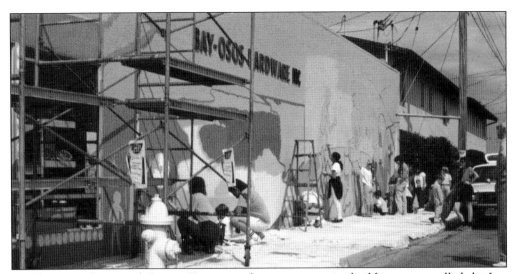

The bear mural inspired George Kastner to form a community-building group called the Los Osos Community Organization (LOCO), which planned the second mural for the Bay-Osos Ace Hardware store on Ninth Street at Los Olivos Avenue for 1990. There were 120 people who chipped in $5 to paint on the wall. Janice Sharman-Hand designed a Chumash village at Spooner's Cove in Montaña State Park. Sharman-Hand's assistants were Ann Calhoun, Jeanne Fennerman, and Martha Wright. It was public art by the people, for the people. (Courtesy of Janice Sharman-Hand.)

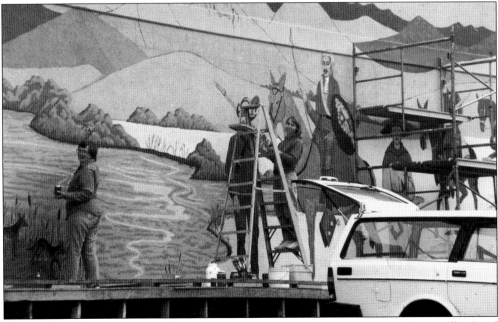

The third mural went on the wall of a convenience mart by a gas station at Los Osos Valley Road and Ninth Street in 1993. This mural was called *Portola's Sacred Expedition* and shows the trek through the Los Osos Valley in 1779. Again, the design was created and the public directed by Janice Sharman-Hand. Other murals exist in town. *Loreto Sunrise* by John Ramos is on Sunset Drive, and an unnamed one is on Second Street near Santa Ysabel Avenue. Out of sight is *Audience of the Bears* at Baywood Elementary School. (Courtesy of Janice Sharman-Hand.)

The mural called *The Baykeeper* was once on the Ross Building on Second Street. It commemorated Sandal Markara and his son, Prince Paka Digones. Markara once rented the building for his shop. He was a free spirit who eschewed the term "hippie" and drugs. He worked stitching sandals and crafting metal sculptures. He claimed to be 5,989 years old. His nickname "Baykeeper" came from watching untended boats, protecting wildlife from harassment, and alerting the harbor patrol in Morro Bay to needed rescues. In 1968, Makara and his son lived on a self-constructed 26-foot-long houseboat made from scrap lumber. For a time, he used a tombstone for an anchor. Markara was a resident on the water until 2004. He died aboard his boat, moored off Baywood Point. (Above, author's collection; below, courtesy of Tim Frein.)

There are two roadways into Los Osos; both are guarded by cement statues representing the numerous bears that once roamed freely and plentifully throughout the valley. These 1,000-pound statues are called the *Greeting Bears* and were designed and painted by Santa Fe artist Paula Zima in 1992. The nickname given to California when it was an independent nation was "the Bear Republic," and California is still known as the "Bear State." Bear statues abound in Los Osos/Baywood Park. (Author's collection.)

South Bay Community Park was the venue for one of the Bearfest events that the Los Osos/Baywood Park Chamber of Commerce put together to engage community spirit. Hundreds of people participated. Yoshiko Smith designed the bear. Tutt's Tree Service provided the crane in 1990, and Pacific Gas and Electric did so in 1991. (Photograph by Roland Muschenetz, courtesy of the Los Osos/Baywood Park Chamber of Commerce.)

Artist Paula Zima created a fiberglass, full-size mock-up of her bear statues soon to be cast in concrete. Here, the model is being carried across the lawn of Don Edwardo's Mexican Restaurant to a ceremony on the front lawn. Local residents who contributed funds toward the project celebrated there on November 24, 1991, with an art show, music, and dancing. (Courtesy of the Los Osos/Baywood Park Chamber of Commerce.)

Sylvia Smith (seated) is flanked by unidentified party guests. Smith holds a miniature of the full-sized, 42-inch-long bear statues that were inspired by a trip to a Northern California Klamath River bridge that had two similar statues. Smith was a community businessperson and activist, Citizen of the Year, member of the first community services district board, and president of the chamber of commerce. (Courtesy of the Los Osos/Baywood Park Chamber of Commerce.)

Los Osos resident and Congressional Gold Medal recipient Dorothy Rooney was 25 years old when she signed up to be a Women Airforce Service Pilot (WASP) during World War II. Over 25,000 women applied; only 1,074 were accepted. Rooney says that her favorite plane to fly was the North American AT-6/SNJ Texan. WASPs were belatedly awarded veteran status in 1977 and the Congressional Gold Medal in 2009. Rooney competed in the Senior Olympics at the age of 70. She still paddles her boat out on the bay at 97 years old. She married her partner Liz Blake in 2015. (Courtesy of Dorothy Rooney.)

Zelle Diefenderfer was also known as "the Sergeant" for helping stressed families; "the Queen" because she knew everyone and everything; and "the Admiral" for getting the Women's Club built. She excelled at finding skilled workers and persuading them to work for free. She kept them organized and working. She also maintained the building after it was built. She died at 102. (Courtesy of Joan Sullivan.)

Katherine "Kitty" Schaffer, a community activist, was instrumental in starting People Helping People in 1972 to assist seniors in need with food, wheelchairs, and walkers. She convinced the county to expand bus service to Los Osos, and she fought for the town library's proper siting. She advocated for creating a community services district that would bring local control to Los Osos. (Courtesy of Joan Sullivan.)

Julie Orr personified community service. She was instrumental in getting the community center built, getting lighting installed downtown in Baywood Park, organizing Oktoberfest, and selling tickets and getting donations for many different causes and fundraisers. (Courtesy of Jerry Orr.)

Al Switzer served on a number of county-based advisory committees for Los Osos/Baywood Park but is best known for his donations: 6.2 acres for the Los Osos Community Park, two acres for St. Elizabeth Ann Seton Catholic Church, 24 acres for Sweet Springs Nature Preserve; and $1.7 million toward the purchase of the Los Osos Greenbelt. Switzer designed and lived in Morro Shores Mobile Home Park. (Courtesy of Pandora Nash-Karner.)

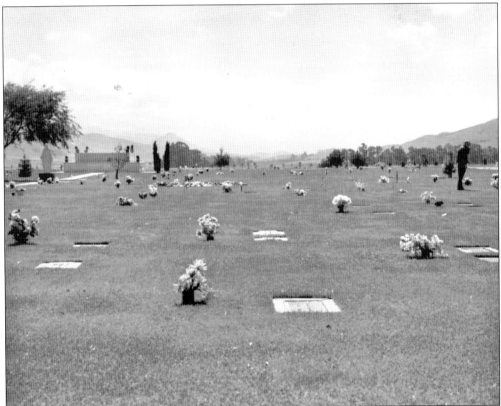

Los Osos Valley Memorial Park is a nonsectarian, nondenominational endowment care park founded in the early 1960s. Compared to other county cemeteries, it is large, with a mausoleum, memorial walls, a columbarium, vaults, and several sections for veterans. Fitting the area, the headstones are flat, so the eyes are directed to the beauty of the Irish Hills, Hollister, and the other volcanic peaks. (Courtesy of the Los Osos Memorial Park & Mortuary.)

Art Clokey and Gumby are national treasures and are recognized worldwide. Until he died, few knew that Clokey lived in Los Osos. Like most Los Osos residents, Clokey lived elsewhere before moving here. He attended film school at the University of Southern California. In the 1950s, he got his big break in Hollywood. He tutored the son of Hollywood mogul Sam Engel, who liked Clokey's animation work. Engel asked him to create little figures out of clay; Gumby was born in 1956. Clokey said "Gumby is a product of light, and light is love." Gumby is one of the great green characters in the world of fiction. On March 10, 1986, a life-sized Gumby character visited Baywood Elementary School to honor trees. Clokey would give kids in town Gumby figures with his signature. Clokey, Gumby, and the other characters will live on in our imaginations. Clokey and Gumby fit well in the persona that is Los Osos/Baywood Park. (Courtesy of Premavision Inc., © 2016. Gumby and Gumby characters are registered trademarks of Prema Toy Company, Inc. All rights reserved.)

Six
Parks and Open Space

Los Osos/Baywood Park is surrounded by lands set aside from development, adding much to its feeling of seclusion and protection. Some are parks: the 90-acre El Moro Elfin Forest Preserve, against the bay on the northern end of town; Morro Bay State Park, which sweeps around the Morro Bay National Estuary and borders Los Osos Middle School on the east; and the 90-acre Los Osos Oaks State Reserve on the southeast. South of town is the 10,000-acre Montaña de Oro State Park, one of the largest in California, which includes the sand spit to the west of town across Morro Bay; the 18-acre Monarch Grove Natural Area; and the 30-acre Sweet Springs Nature Preserve on the bay.

The recreation area in town includes the Los Osos Community Center, the Red Barn, the historic Los Osos Schoolhouse, tennis courts, a skate park, and a playground. Surrounding the Los Osos Library is the 11-acre mitigation land for the Los Osos sewer project, with a walking trail through native plants. The Broderson area is more land set aside as sewer mitigation (and a leach field), and is crisscrossed with hiking and horse trails. There are other in-town natural areas with trails that are somewhat secret.

A small, unofficial park with a beach, Pasadena Park, is often used to launch kayaks. The Audubon Overlook, a platform for bird observation at the end of Fourth Street, was created by the Coastal Access Law. On a smaller scale, there is a tiny pier and a tiny park on Second Street with one picnic table, the town's first park, created in 1954.

None of these parks happened without a large amount of hard work by volunteers and the perseverance of Los Osos residents, along with good luck and a lot of help from the State of California, County of San Luis Obispo, Land Conservancy of San Luis Obispo County, Los Osos/Morro Bay Small Wilderness Area Preservation chapter (SWAP), Morro Coast Audubon Society, Coastal San Luis Resource Conservation District, US Bureau of Land Management, and private landowners.

The story of the acquisition of the exquisite Elfin Forest is perhaps the most complex of all of the parks in Los Osos. The land was owned by Shirley Otto, widow of early Baywood Park developer Richard Otto. The Estero Chapter of SWAP, formed in 1972, thought that it had protected this area from development, so in 1979, it disbanded. But the 90.2-acre "Otto Property" parcel remained in Shirley Otto's hands. She was approached by developers who wanted to build 132 homes on the bluff above the estuary. A group of concerned neighbors, organized by Carol Larson and Yolanda Waddell and including Larry and Pat Grimes and Myron Graham, formed the organization Save the Bay to preserve this land. In 1985, they became the Los Osos/Morro Bay Chapter of SWAP. (Above, photograph by Scott Glancy; below, photograph by Yolanda Waddell; both, courtesy of SWAP.)

In 1986, the state purchased the northern 51.6 acres of what Pat Grimes named the El Moro Elfin Forest. That left 38.6 acres of Otto property to buy. SWAP went to work to gain community interest, collect scientific data, and contact county, state, and other governmental agencies for funds to purchase the land. In 1989, SWAP was joined by Shanda Gibbs, Rose and Les Bowker, Barbara Machado, and Jerry and Elsie Dietz. Barbara and Rose began paying visits to Shirley Otto, saying that SWAP was serious about buying the land. Shirley was interested. Above, the SWAP members pictured in May 2014 are, from left to right, Yolanda Waddell, Les Bowker, Barbara Machado, Elsie Dietz, Jerry Dietz, Pat Grimes, and Larry Grimes. Rose Bowker is pictured below speaking at the dedication of the boardwalk in March 2000. (Above, photograph by Pat Brown; below, photograph by Katy Budge, courtesy of SWAP.)

Rose Bowker led the raising of $1.25 million in grants: Caltrans donated a $500,000 Environmental Mitigation and Enhancement grant, the California State Lands Commission provided $100,000, $500,000 came from federal transportation enhancement funds earmarked for San Luis Obispo County through the California Transportation Commission, and a county-wide fund drive raised $100,000. In March 1994, there was still a gap of $125,000. The deadline for the Elfin Forest to go into escrow was April 1994 or it would be in jeopardy of losing the grants. The San Luis Obispo Board of Supervisors chipped in the last $50,000, and the forest was saved by 2,700 individuals, organizations, businesses, and county, state, and federal agencies. San Luis Obispo County Parks contracts with SWAP to manage the land. This photograph was taken in June 1994 during the celebration of the purchase of the second parcel and the mural of the park painted on the Los Osos Rexall building by local artist Barbara Rosenthal. (Photograph by Larry Grimes, courtesy of SWAP.)

Above, some of the volunteer "Weed Warriors," (from left to right) Norma Wightman, Yolanda Waddell, and Ron Rasmussen, are doing work to maintain the park, digging up invasive plants such as veldt grass and slender-leaved ice plant. They are being very careful in the habitat of the federally protected Morro shoulderband snail. There are no paid maintenance people, but SWAP applies for grants from private foundations and agencies such as the Morro Bay National Estuary Program for projects beyond the volunteers' scope. Walks and talks, as entomologist and photographer Dennis Sheridan is doing below, are given monthly by volunteers for anyone who cares to join. They cover such topics as bird watching, geology, botany, and archeology. (Above, photograph by Alon Perlman; below, photograph by Yolanda Waddell; both, courtesy of SWAP.)

The Los Osos Oaks State Natural Reserve was a park rushed into existence and saved from development within a two-week period in the summer of 1972 by Emily Polk. She saw a "For Sale" sign and called to find that 32 acres of ancient coast live oaks owned by the Machado Estate were to be sold in 15 days for a mobile home development. Polk had formed SWAP the year prior to save areas such as these. Her partners were Ansel Adams, Margaret Owings, and Edgar Wayburn. Photographs and archeological, zoological, and botanical data were rushed to the state parks director, whose assistant convinced him that 58 acres of the adjacent Eto ranch should be saved as well. Three days from the deadline, Polk, still lacking the needed funds, called a friend whose husband owned Dart Industries. He donated $254,000. The other half of the money was put up by federal funds, with a small portion by the California State Parks Foundation. (© the *Telegram-Tribune*/Larry Jamison.)

A Mozart concert is being played under the oaks, but docent-led hikes and photography are more common sights. The park features ancient sand dunes covered with coast live oak trees hundreds of years old. Botanists list five major plant communities in the reserve: coastal sage scrub, central coastal scrub, dune oak scrub, coast live oak forest, and riparian. The oak scrub has dwarf oak trees growing six to eight feet tall on the sand dunes. Larger coast live oaks are located where the soil has more water, and can grow to 25 feet tall. Both types are very gnarled and dramatic in shape. (Courtesy of Marlin Harms.)

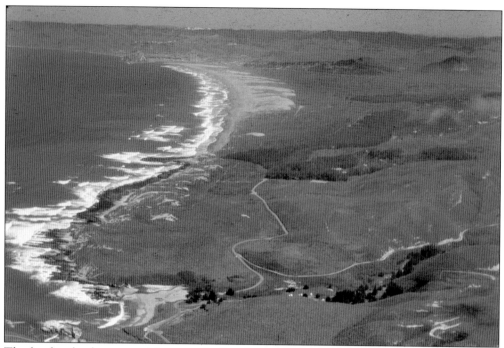

The land today known as Montaña de Oro State Park was first inhabited by the Northern Chumash. Capt. John Wilson's Rancho La Cañada de Los Osos y Pecho y Islay came next. Three generations of Spooners raised crops and owned a dairy. They leased the land to Japanese farmers, who were abruptly ousted during World War II. Oliver C. Field bought it, and parts of the Hazard Ranch, in 1942. He sold it in 1954 to Irene Starkey McAllister. She was in trouble financially by 1960, and the property went into federal receivership. California bought it in 1965. Bureau of Land Management lands were added later, as was Field's 1,400-acre Hazard Canyon parcel, to total around 10,000 acres. McAllister's naming the land "Montaña de Oro" is a mystery; it is not known whether she meant the gold color of the sticky monkey flowers and mustard fields or a tribute to her husband's home state, Montana. (Above, courtesy of the California State Parks and the Central Coast State Parks Association; below, author's collection.)

Richard McKillop was the first ranger assigned to the new Montaña de Oro State Park in March 1965. He noted that the park had no facilities on the 4,400 acres for park visitors when it opened; many improvements needed to be done. He painted the outbuildings, helped develop the campground, and led interpretive hikes. He named many of the trails, coves, and other features. McKillop had a long and distinguished 33-year career as a California State Park ranger and interpretive specialist. He considered Montaña de Oro the "crown jewel" of his career. The photograph below, taken by McKillop at Spooner's Cove, shows, from left to right, Wes Cater, manager of Hearst Castle; unidentified; and William Penn Mott, director of the California State Parks and Recreation Department. (Right, courtesy of Sherry McKillop; below, photograph by Dick McKillop, courtesy of the California State Parks and the Central Coast State Parks Association.)

The park was bereft of amenities such as decent roads and sanitary facilities, so the state began to create a more usable park, one that was still rugged but would accommodate camping and provide 65 miles of trails for both hikers and horseback riders. The eventual 8,000 acres, once acquisition of land was complete, holds 473 species of plants, a variety of birds, black bears, mountain lions, coyotes, and bobcats. It has no entrance costs. There are several wellheads from exploration for oil that did not pan out, and 16 springs. The photograph above is from 1966, and the one below is dated September 3, 1967. (Both, courtesy of the California State Parks and the Central Coast State Parks Association; below, photograph by Dick McKillop.)

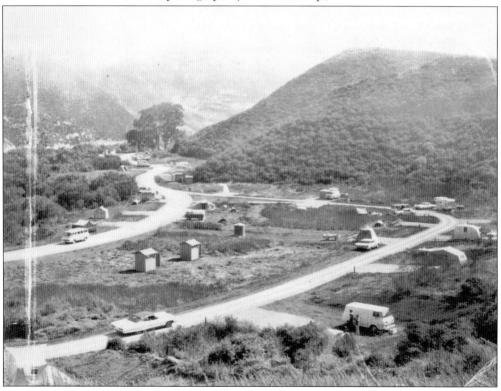

The buildings on Hazard's property were wiped out by a flood in the early 1940s, and what was left burned in 1947. With the exception of the Spooner house (pictured), nothing remained of the many wooden structures the Spooner family had built. The old life and times were celebrated on the 100-year anniversary of the Spooner ranch house on August 8, 1992, by, from left to right above, Phyllis Snyder, Oscar Brooks, Joe Silva, ? Spooner, Don Spooner, ? Spooner, and docent Ernie Eddy. (Both, courtesy of the California State Parks and the Central Coast State Parks Association.)

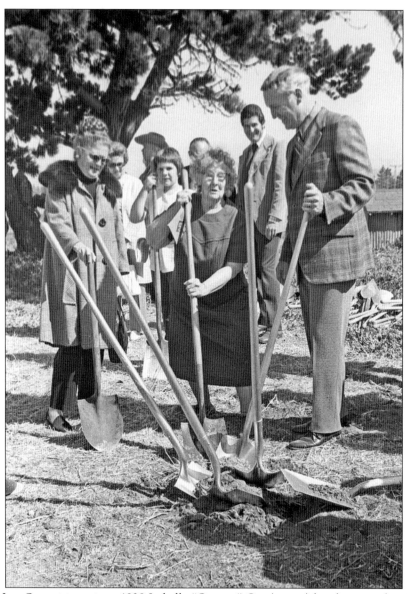

Notable Los Osos citizen since 1928 Isabelle "Granny" Orr (center) breaks ground on June 13, 1973, for the 6.2-acre community park on Palisades Avenue that she had been promoting for years. The man on the right is Second District supervisor Elston L. "Buzz" Kidwell; developer John Curci, who donated the property along with Al Switzer, is between them. Orr was also a force behind saving the Los Osos School, once located at the intersection of Los Osos Valley Road and Turri Road, by moving it to the park for preservation. The park dedication ceremony was on February 7, 1976. This park was a joint effort between the Citizen's Service Club, businesses that provided money and materials, the board of supervisors that funded it, county planning and Cal Poly students who designed it, the San Luis Obispo County Department of Parks and Beaches, the San Luis Obispo County Office of Facility Services, and the South Bay citizens who constructed it, led by contractor Robert "Bob" Crizer. The park was called the South Bay Community Park until 1999, when the name changed to Los Osos Community Park. (© the *Telegram-Tribune*/Larry Jamison.)

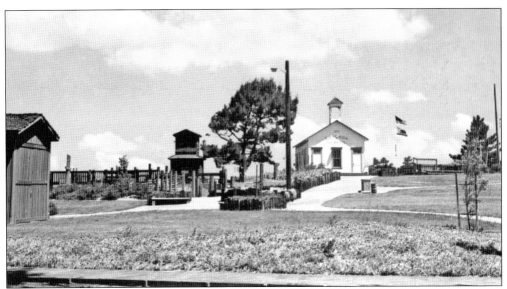

The Los Osos Community Park started with a plan and the Los Osos Schoolhouse, which once moved was almost entirely replaced due to termite damage. The missing bell is a lingering mystery. The Red Barn, original to the property, was restored by citizens. The county's well sits between the two buildings. The park cost $175,000, and maintenance was $24 per year. Today, a skate park has replaced the lawn in this view. (Courtesy of the History Center of San Luis Obispo County.)

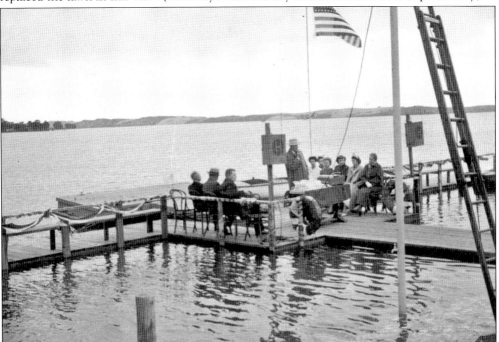

The Los Osos Pier opened on January 9, 1955, with Superior Court judge Ray B. Lyon making the dedication speech. Developer Richard Otto donated $2 for every $1 the chamber of commerce raised to build the pier. The land around it, though small, was considered a park, and a controversy over ownership 20 years later ensued: no one seemed to own it. (Courtesy of the History Center of San Luis Obispo County.)

The Los Osos Greenbelt comprises lands surrounding Los Osos that were protected by the Morro Estuary Greenbelt Alliance (MEGA), founded in 1998 by Marla Morrissey. She teamed with John Chesnut and David Chipping, as well as photographers Marlin Harms and Dennis Sheridan. Six hundred acres of pristine dune scrub in 19 privately owned properties were purchased and conserved in perpetuity. Numerous government agencies and the Trust for Public Land were involved. Some land was mitigation from damage caused by five trans-Pacific cables in Montaña de Oro. The Bureau of Land Management added more. Al Switzer's 200-acre Bayview piece connected the Oaks to Montaña de Oro. Many acres are undergoing restoration from farming, easing the load of sediment filling in Morro Bay. Below, Gigi Ballinger Penton studies a shell left by the Northern Chumash. (Above, author's collection; below, courtesy of Marlin Harms.)

Sweet Springs Nature Preserve started as the 1893 development Sunshine Beach, which failed. Walter Redfield and Richard Otto both likely owned it. Emma and Charles Ferrell ran a hunting lodge. William and Linda Mickle farmed from the 1920s to 1948, when Henry Bumpus purchased it. Harold and Orlien Broderson purchased the central section in 1948, and Bumpus sold part to Jan and Tom Corr in 1972. Al Switzer's Morro Palisades Company purchased it in 1957, and in 1968 planned a boat launch and a park with playground and tennis courts; in 1978, the Corrs offered an acre for the library. In 1981, a hotel was proposed. All these plans failed due to public protest. Al Switzer then donated the land to the California Coastal Conservancy, which donated it to the Morro Coast Audubon Society; the park dedication was on September 12, 1986. (Above, courtesy of Marlin Harms; below, author's collection.)

The Morro shoulderband snail (*Helminthoglypta walkeriana*), native to the Los Osos area, was listed as an endangered species by the US Fish and Wildlife Service on December 15, 1994. Since then it has become everything from an imaginary mascot to a dreaded foe due to its protected status and the regulations to be followed in order to build a new structure if any snails, dead or alive, are found on a property. A US Fish and Wildlife–authorized biologist must assess for their absence to obtain a building permit, or mitigations must be made if "take" is unavoidable. The "snailmobile" below was created by SWAP volunteers and rolled down Los Osos Valley Road in the December 2005 Los Osos Christmas Parade. (Above, courtesy of San Luis Obispo County Department of Public Works; below, courtesy of Bob Meyer.)

Seven

THE INFAMOUS SEWER AND SELF-GOVERNANCE

Los Osos is known in governmental agencies from California to Washington, DC, for its sewer controversy due to an unprecedented default on a $134-million loan to build a sewer. The story starts in the 1920s with household waste of every type being funneled into septic tanks, leach fields, and pits. The population had only reached 600 by the 1950s, so septic tanks sitting on top of the town's only water supply, a layering of aquifers, was not yet a problem. New housing boomed from the 1960s through the 1980s. Concern blossomed when the esteemed water, once deemed "the purest and softest water in the world" by Richard Otto, was too polluted with nitrates to drink in one aquifer, and the other was drawing in the ocean's saltwater from over-pumping.

The state intervened in 1971, mandating a fix. The County of San Luis Obispo was tasked, as Los Osos was a rural area under its jurisdiction. Then the questioning began. Was it household pollution causing the problem, or the residue from farms in the valley? How much was this sewer going to cost, and who was going to pay for it? A host of delays ensued to halt this decision-making, using lawsuits, differing technologies, and the need for further studies as reasons.

The question of whether or not to become a community services district (CSD) to have local control over sewerage arose in the early 1970s but failed to pass in 1979 and in 1991 (there was not enough commerce to support cityhood). In 1999, strong opposition to the county's much-delayed sewer plan created the Los Osos CSD, a child of the state, not the county.

What was to be a $34.6-million sewer in 1984 and almost 90 percent paid for by the federal government expanded to a $183-million sewer by 2016 to be paid for almost completely by residents. The story could be called a cautionary tale or a tragedy, but with dissent being a feature of the community character, Los Osos survives and plunges forward into the future, slower and dented, but unbent.

Pictured here is a septic tank being installed. This model is from the 1970s and looks modern today. But tanks from the 1920s and on, some of which were simple redwood barrels, had not been replaced, and problems (and sometimes the tanks themselves) arose, especially during floods. (Courtesy of Bobbi Breen-Gurley.)

In 1998, the 968 signatures required to put voting for a CSD on the ballot were collected. The community voted yes with an 87 percent majority. The first board celebrated its victory; from left to right are Stan Gustafson, Sylvia Smith, Pandora Nash-Karner, Rose Bowker, and Gordon Hensley. Their main objective was to gain control of the sewer project. (Courtesy of Annie Mueller and the Los Osos/Baywood Park Chamber of Commerce.)

Attorney John Burnham sits on a "throne" at the grand opening of the Los Osos CSD offices on Ninth Street in 1999. Burnham wrote the legal papers to petition the Local Area Formation Commission (LAFCO) to form the Los Osos CSD (LOCSD). LAFCO bestowed the parameters of control the LOCSD would have over the 3,443 acres of Los Osos: the Baywood Park County Water District (formed in 1935); the South Bay Fire Protection District (formed in 1959); County Service Area No. 3 for drainage; County Service Area No. 4 for street lights, additional drainage, and park and common grounds maintenance (both formed in 1964); and solid waste. (Courtesy of Pandora Nash-Karner.)

A septic tank truck in a Christmas parade is not too strange for Los Osos. A densely built town, all on septic tanks, was the result of septic tank permitting being removed from the county's Environmental Health Division and being turned over to the Building Department. (Courtesy of Pandora Nash-Karner.)

The Royal Flush Sewerfest was a community celebration of unity in October 1997, resolving to "avoid pollution without destitution." The event included a parade, a sewer poetry writing contest, and games such as musical toilets. Nitrate-free hot dogs were served. From left to right are Melissa McFarland (snail's head), Dave Mayfield (kneeling), Carlene Davis (kangaroo rat), Sylvia Kneller, Virgil Just, and Sandra Hedges. (Courtesy of Jan Mayfield.)

Thousands of words filled the local papers beginning in 1970, when the community found that incessant growth with no infrastructure had compromised the water supply. Cartoonists had a field day, as San Luis Obispo New Times' Russell Hodin illustrated in 2004 with Rodin's The Thinker. The sewer was a topic tossed between those who wanted the county's project, those who wanted a different project, and those who wanted no project. (Courtesy of Russell Hodin.)

This 2005 display on Los Osos Valley Road signaled the possible result of failing to build a sewer ordered by the Regional Water Quality Control Board. A successful recall election in September, which would replace three CSD directors with new directors wanting a different sewer at a different location, could leave the community paying up to $10,000 a day to flush. (Photograph by Neil Farrell, courtesy of the Bay News.)

A new group formed in January 2005 supporting the LOCSD's sewer, which had been planned since 2001 but which had been slowed by numerous lawsuits and appeals. The opposition had grown very strong, and the project was being challenged at every turn. There was a very real possibility that this sewer project, too, would be stopped. (Photograph by Neil Farrell, courtesy of the Bay News.)

Ground breaking at the sewer site, "Tri-W," took place on July 8, 2005. Both pro and con supporters of the project were out in force at the raucous meeting. Measure B, a plan to stop the current sewer, was on the September ballot, and it was a close fight. During the ground breaking, two directors tossed away their gold-painted shovels and left the ceremony. (Photograph by Neil Farrell, courtesy of the Bay News.)

The ballot measure to stop the sewer project passed by 19 votes, three directors were recalled, and lawsuits began flying like New Year's Eve confetti. The new board, sued by the sewer contractors, the State of California, and the water board, went bankrupt. Legislation by state assemblyman Sam Blakeslee to take the sewer project away from the LOCSD and give it to the state passed with all "yes" votes. Gov. Arnold Schwarzenegger signed the bill into law on January 1, 2007, and the county was once again creating another sewer project. The digging finally began in 2012, and this photograph from 2013 shows crews repaving where the gravity pipes for the new sewer were in place, more or less ending the 35-year conflict. (Author's collection.)

DISCOVER THOUSANDS OF LOCAL HISTORY BOOKS FEATURING MILLIONS OF VINTAGE IMAGES

Arcadia Publishing, the leading local history publisher in the United States, is committed to making history accessible and meaningful through publishing books that celebrate and preserve the heritage of America's people and places.

Find more books like this at
www.arcadiapublishing.com

Search for your hometown history, your old stomping grounds, and even your favorite sports team.

Consistent with our mission to preserve history on a local level, this book was printed in South Carolina on American-made paper and manufactured entirely in the United States. Products carrying the accredited Forest Stewardship Council (FSC) label are printed on 100 percent FSC-certified paper.